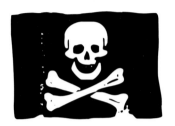

FLORIDA PIRATES

FROM THE SOUTHERN GULF COAST TO THE KEYS AND BEYOND

JAMES KASERMAN & SARAH KASERMAN

THE History PRESS

Published by The History Press
Charleston, SC 29403
www.historypress.net

First published 2011
Cover images: map courtesy of Geography and Map Division, Library of Congress;
other images courtesy of Florida Archives

Manufactured in the United States

ISBN 978.1.60949.419.3

Library of Congress Cataloging-in-Publication Data

Kaserman, James F.
Florida pirates : from the southern Gulf Coast to the Keys and beyond / James and Sarah
Kaserman.
p. cm.
Includes bibliographical references.
ISBN 978-1-60949-419-3
1. Pirates--Florida--History. 2. Privateering--Florida--History. 3. Blockade--Florida--
History. 4. Pirates--Florida--Biography. 5. Seafaring life--Florida--History. 6. Gulf Coast
(Fla.)--History. 7. Florida Keys (Fla.)--History. 8. Atlantic Coast (Fla.)--History. 9. Florida--
History. 10. Florida--Biography. I. Kaserman, Sarah Jane. II. Title.
F311.K37 2011
910.4'5--dc23
2011042386

This book is dedicated to Mr. Robert Hise, a high school history teacher and University of Illinois graduate who taught in 1956 that among the cruelest pirates in history were those on the Ohio River. He also stressed that the United States probably would not have won the Revolutionary War were it not for the 3,500 privateers, or pirates, who were the mainstay of the Continental navy.

We would also like to dedicate this book to our sons, their wives and our three grandchildren: son Rick, his wife Louise and their sons, James Hunter and Reed Samuel, as well as son James, his wife Shannon and their daughter, Haven Jade.

CONTENTS

Acknowledgements

We want to acknowledge the many historians, students, individuals, agencies and others who, over the years, gave us advice, support, encouragement and help in preparing this book.

Also, we thank Patricia Clous of Westerville, Ohio, and Jeff Bridgman of Asheville, North Carolina, for their reading, questioning, and initial editing of this book.

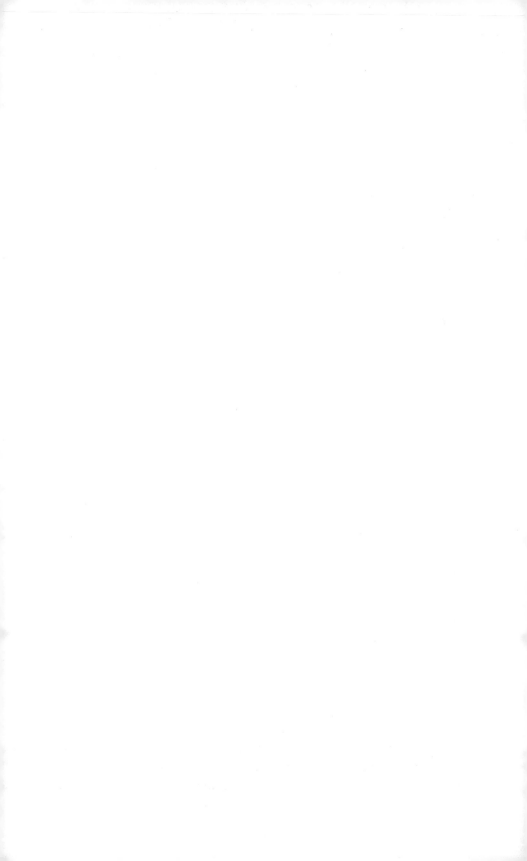

INTRODUCTION

Piracy—the capture and robbery of ships and their cargo, crew and passengers—has existed since men and women first began using the rivers and seas to trade. Piracy is one of the historical institutions that exists outside of government law, for various reasons. The foremost is economic—the perceived reward far outweighs the personal risk to the pirate. The pirate's motto throughout history, "No prey, no pay," gives us understanding of this concept. Piracy has always been a performance-driven enterprise.

Piracy has also historically risen after periods of major naval wars, when many sailors found themselves unemployed and, for economic reasons, needed to continue their sailing careers. In addition, intense nationalism and religious fervor were sometimes factors in pirate attacks.

Pirates are typically *of* the sea, and so their targets and operations occur on the water or in cities and towns along the seacoasts and rivers. Since a majority of people live near water, and transportation over water is the least expensive way to ship items, piracy has always been a part of our history, and it continues to this day.

There are thousands of pirate legends and stories. Most people read about and relate to famous pirates who sailed during the "Golden Age" of piracy, the period from roughly 1650 to 1730, or to the pirates and privateers who sailed during the formation of the United States during the period of 1775–1821. The authors and historians of these periods often created images of pirates as freedom-loving individuals willing to battle the established systems and hated monarchies, people who were

to be admired as heroes to the many communities that benefited from their existence. Since governments employed pirates under the guise of "privateers," it was only natural that many national military naval heroes had some background in piracy.

As we will learn, a pirate's life, unlike those images created in fiction or movies, was a difficult life; it was a rugged existence that typically lasted only a few years. In reality, pirates had much to fear from their peers, law enforcement, legal authorities and the physical and health risks associated with being at sea during the times they lived. When not glamorized, most pirates were thought of as thieves, criminals and murderers.

The history of pirates takes us back to the Greek pirates who operated along their coast nearly three thousand years ago. These pirates typically attacked ships from land, rowing out in small boats to raid vessels off the coast. One Greek myth tells of how the god of wine and celebration, Dionysus, caused the Greek pirates to jump into the sea, whereupon he changed them all into dolphins. Factually, the Athenians destroyed two hundred Persian ships, many of them privateers, in the Battle of Salamis in 480 BC, which preserved Greek independence and is considered one of the most important sea battles in history.

The Roman empire of later years was in constant attack by pirates from the southern coast of Turkey. These rogues terrorized hundreds of coastal towns in the empire. In 78 BC, young Julius Caesar was captured by the pirates of Cilicia and held for ransom, which he paid. Four years later, he was captured again and held on the island of Pharmacusa. Since he was insulted with the low ransom being demanded, he insisted it be doubled in accordance with his stature as an aristocrat. He also promised to crucify the pirates after he was freed. When the amount was raised by his friends and he was released, he gathered a small force and captured and killed the pirates.

Julius Caesar was captured by pirates in 78 BC. *PD-US.*

The pirates of Cilicia gained such a grip on Mediterranean trade that the Romans faced starvation and had to pass a bill in 67 BC to stamp out piracy. The resultant campaign, under the famous Roman general Pompey, did away with more than ten thousand pirates and established mivlitary patrols to protect the Mediterranean.

Around the time of AD 700, Viking pirates attacked and looted many European countries, including England, France, Germany, Ireland, Italy, Russia and Spain. In the Norse language, the word "Viking" means "sea raider," and these Vikings were natives of Norway, Sweden and Denmark. After a council decided to attack a prey, galleys (or boats with oars as the main means of propulsion) were utilized. The Vikings were fearsome warriors with swords, battle axes, knives, shields and helmets for protection. Some of these helmets had horns from animals on them. The expression "to go a Viking" meant to fight like a pirate. Like the pirates before them, they plundered ships and settlements, took treasures and held captives for ransom. Unlike earlier pirates, many of the Vikings settled down in the areas they invaded and raised families.

The Barbary pirates, or corsairs, operated in the Mediterranean Sea during the Middle Ages and beyond. They initially lived on the northern coast of Africa in countries called Barbary states and primarily in the ports of Tunis, Algeria and Tripoli. Unlike other pirates, the main purpose of the Barbary pirates, who were of the Muslim faith, was to capture Christian slaves for the Islamic market in North Africa and the Middle East. The wealthy captives were held for ransom. For those who were not successfully ransomed and the poor, the Barbary pirates either enslaved them in Christian prisons called bagnios or sold them as slaves on the open slave market. The corsairs wore the traditional dress of the Muslim lands of the North African coast. They not only seized ships but also raided European coastal towns and settlements, particularly along the coast of Italy and Spain.

On October 7, 1571, Christian Mediterranean nations united to win the Battle of Lepanto in the eastern Mediterranean against the corsairs. This marked the last widespread use of the oared galleys that had been around since the days of the Phoenicians, and the Barbary pirates then began to utilize sails and shipbuilding techniques that they had learned from the European pirates. The Barbary pirates in later years were the focus of an attack by the United States of America in 1805 that included the formation of the United States Marines. The United States, tired of paying almost 20 percent of its national budget to the Barbary pirates, declared war on the corsairs to end this practice.

Tribute to the Barbary pirates. *PD-US.*

State marker on the 1821 Porter pirate raids. *Florida Archives.*

Throughout history, pirates have also roamed the seas of the Far East. They primarily sailed in two- and three-masted wooden sailing ships called junks. Chinese pirates wore their hair in pigtails and donned loose-fitting clothing in which they carried bows and arrows, many knives and unique curved short swords. Both men and women served as pirates in these Chinese pirate fleets. During the 1600s, pirates under the command of Cheng Chih-Lung sailed on the South China Sea with more than one thousand ships. In the early 1800s, the famous female pirate leader Zheng Yi Sao or Ching Shih had more than seventy thousand men and women sailors and thousands of ships at her command.

Another stage for piracy opened on October 12, 1492, when Italian explorer Christopher Columbus, sailing under the flag of Spain, landed on Salvador Island in the Caribbean Sea. This opened up the Western Hemisphere, known as the New World, for exploration, trade and colonization and set the stage for the most famous explosion of piracy in the history of the world to that point. This book will focus on some of those pirates of south Florida and the Florida Keys. Enjoy your journey to understanding piracy of the past, present and future. As the historical marker shown here reads, at any given time, there are or have been literally thousands of pirates in our midst; we are choosing only a representative few of the most famous or infamous.

Ϧιστορικαl Βαckgρουνδ

Nearly twenty centuries have passed since pirates captured Julius Caesar in 78 BC, making him one of the most recognizable figures in recorded history held for ransom. Piracy has occurred anywhere there is commerce, including oceans, lakes and rivers. In the middle of what is now the United States, some of the most brutal pirates, known as the "Ohio River Pirates," operated from the 1790s to the 1870s from Cave-in-Rock, now a state park in Illinois. Their cave was first discovered by the French in 1729. It was most famous as a hideout for river pirates, robbers and murderers, as well as a band of counterfeiters to boot. The inland pirates were the inspiration for a Walt Disney adventure movie, *Davy Crockett and the River Pirates*, filmed at Cave-in-Rock in 1956. After law came to the Illinois Territory, the cavern served as a shelter for pioneers heading west.

Piracy, in many forms, continues to this day and will continue to challenge law enforcement worldwide, including the waters that surround Florida. From the traditional acts of plundering through human smuggling, billions of dollars are snatched annually by pirates.

Over the past three hundred years, songs, plays, films, literature and poetry have suggested romantic ideals and stereotypes about pirates. Since handwritten records could be used against them in a court of law, pirates left few scripted accounts. The authors and reporters of the day often lionized pirates, particularly those who plied the trade during the Golden Age of piracy and the settling of the Caribbean ocean islands. Much of the

Inside Cave-in-Rock overlooking the Ohio River. *Kaserman Photo.*

art, including woodcuts and engravings that represent pirates and pirate life of that era, is as false as the many tales of buried treasures.

One reason for the glamorization of pirate criminals in literature and art is the human desire for individual freedoms. A pirate was portrayed as leading a life of adventure, free from the laws and bureaucracy of government and the cultural and moral conventions followed by civilized societies. Pirates attacked governmental authority and rebelled against oppressive working conditions. These restless men of the sea had their own form of democracy, and many crews treated men and women equally, regardless of race. At sea under dismal conditions much of their careers, when pirates came ashore, they often bought fine and colorful clothing, drank and ate heartily, laughed, danced and partied during their time at dock. For average citizens, the pirate way of life was completely different from the controlled, disciplined and difficult life that they were expected to lead. This, in part, explains how the perceived life of a pirate was quite different from reality.

But before we criticize or condemn writers of pirate history, it is important to recognize that truth is often stranger than fiction. Many historical accounts of piracy seem too unlikely to be factual, and many mythical tales seem absolutely true.

As one example of such a historical event, Alwilda, daughter of a Scandinavian king in the fifth century AD, was to enter a marriage arranged by her father, as was the custom. Since the designated groom, Prince Alf, the son of Sygarus, king of Denmark, was not of Alwilda's choosing, she and some of her female friends disguised themselves as men, found a ship and fell in with some male pirates, who elected her captain.

Under her command, Alwilda and her band became a formidable pirate force in the Baltic Sea. Prince Alf was dispatched to hunt down these pirates, and when the ships met, a fierce naval battle took place in the Gulf of Finland. Prince Alf and his men boarded the pirate vessel, killed most of her crew and took Alwilda prisoner. The pirate princess was greatly impressed with Prince Alf's fighting abilities and changed her mind, being persuaded to accept his hand in marriage. They were married on board his ship, and she eventually became the queen of Denmark.

Another "image" problem with pirating came from one's point of view. For instance, a pirate vessel could be a "privateer" to one country while serving as a privately owned navy vessel commissioned to seize enemy ships. The privateer would be considered a pirate vessel, however, by the country whose shipping was attacked.

A privateer was thus a person or ship sailing with a commission historically known as a letter of marque. The letter of marque was issued by a government and typically permitted the privateer to make prizes of enemy ships. In contrast, a pirate was any person who committed acts of piracy on the high seas. Since the privateer and pirate were frequently one and the same, you can more fully understand the historic misunderstanding.

Employing privateers or a privately funded navy to supplement the government-owned navy meant good economic sense for countries and was common worldwide until shortly after the American Civil War. Privateers provided the ship, the crew and all operational costs at no expense to the employing nation in exchange for a percentage of the income of prizes captured. Today, using privateers is illegal, but there is speculation that nations might reconsider privateering to deal with modern-day pirates and terrorists.

The United States of America might not exist in its present form without the employment of privateers in the Revolutionary War and the War of 1812 against England. In the 1770s, the American colonies and the Continental Congress relied heavily on pirates to harass British naval and merchant vessels. More than three thousand letters of marque or privateering commissions were issued during the American Revolution,

IN CONGRESS,

WEDNESDAY, APRIL 3, 1776.

INSTRUCTIONS to the COMMANDERS of Private Ships or Vessels of War, which shall have Commissions of Letters of Marque and Reprisal, authorising them to make Captures of British Vessels and Cargoes.

I.

YOU may, by Force of Arms, attack, subdue, and take all Ships and other Vessels belonging to the Inhabitants of Great Britain, on the High Seas, or between high-water and low-water Marks, except Ships and Vessels bringing Persons who intend to settle and reside in the United Colonies, or bringing Arms, Ammunition or Warlike Stores to the said Colonies, for the Use of such Inhabitants thereof as are Friends to the American Cause, which you shall suffer to pass unmolested, the Commanders thereof permitting a peaceable Search, and giving satisfactory Information of the Contents of the Ladings, and Destination of the Voyages.

II.

You may, by Force of Arms, attack, subdue, and take all Ships and other Vessels whatsoever carrying Soldiers, Arms, Gun powder, Ammunition, Provisions, or any other contraband Goods, to any of the British Armies or Ships of War employed against these Colonies.

III.

You shall bring such Ships and Vessels as you shall take, with their Guns, Rigging, Tackle, Apparel, Furniture and Ladings, to some convenient Port or Ports of the United Colonies, that Proceedings may thereupon be had in due Form before the Courts which are or shall be there appointed to hear and determin Causes civil and maritime.

IV.

You or one of your Chief Officers shall bring or send the Master and Pilot and one or more principal Person or Persons of the Company of every Ship or Vessel by you taken, as soon after the Capture as may be, to the Judge or Judges of such Courts aforesaid, to be examined upon Oath, and make Answer to the Interrogatories which may be propounded touching the Interest or Property of the Ship or Vessel and her Lading : and at the same Time you shall deliver or cause to be delivered to the Judge or Judges, all Passes, Sea Briefs, Charter Parties, Bills of Lading, Cockets, Letters, and other Documents and Writings found on Board, proving the said Papers by the Affidavit of yourself, or of some other Person present at the Capture, to be produced as they were received, without Fraud, Addition, Subduction, or Embezzlement.

V.

You shall keep and preserve every Ship or Vessel and Cargo by you taken, until they shall by Sentence of a Court properly authorised be adjudged lawful Prize, not selling, spoiling, wasting, or diminishing the same or breaking the Bulk thereof, nor suffering any such Thing to be done.

VI.

If you, or any of your Officers or Crew shall, in cold Blood, kill or maim, or by Torture or otherwise, cruelly, inhumanly, and contrary to common Usage and the Practice of civilized Nations in War, treat any Person or Persons surprized in the Ship or Vessel you shall take, the Offender shall be severely punished.

VII.

You shall, by all convenient Opportunities, send to Congress written Accounts of the Captures you shall make, with the Number and Names of the Captives, Copies of your Journal from Time to Time, and Intelligence of what may occur or be discovered concerning the Designs of the Enemy, and the Destinations, Motions, and Operations of their Fleets and Armies.

VIII.

One Third, at the least, of your whole Company shall be Land Men.

IX.

You shall not ransome any Prisoners or Captives, but shall dispose of them in such Manner as the Congress, or if that be not sitting in the Colony whither they shall be brought, as the General Assembly, Convention, or Council or Committee of Safety of such Colony shall direct.

X.

You shall observe all such further Instructions as Congress shall hereafter give in the Premises, when you shall have Notice thereof.

XI.

If you shall do any Thing contrary to these Instructions, or to others hereafter to be given, or willingly suffer such Thing to be done, you shall not only forfeit your Commission, and be liable to an Action for Breach of the Condition of your Bond, but be responsible to the Party grieved for Damages sustained by such Mal-versation.

By Order of CONGRESS.

JOHN HANCOCK, President.

A 1776 privateer document. *National Archives.*

and both piracy and privateering are noted in many of our government's earliest documents.

Robert Morris, one of our Founding Fathers, realized that he could help to finance some of the costs of the Revolution by investing in privateering. Morris bought shares in many of the pirates' seizures. Benjamin Franklin and George Washington also invested in privateering. Many of the famous American privateers, such as John Brown of Rhode Island, increased their wealth dramatically while serving the new nation and their state. Later in life, Brown used part of this fortune to become one of the founders of Brown University.

During piracy's Golden Age, about 1650–1730, these robust and shrewd individuals operated under written articles of confederations that were democratic in nature: each member had a vote on important affairs and was guaranteed a percentage or a share of any and all income from the pirate enterprise. Additionally, each member received legal and due process rights and could be judged only by trial and jury of their peers, referred to as "parleys, where disputes could be settled." In most cases, pirates elected their captains and other officers. Moreover, part of the pirate's written contract was a form of modern-day "workers' compensation" that described how much money an injured pirate would be given for loss of eye, a left arm, a right arm, leg or finger. This transpired during an era when benevolent monarchies and dictatorships were the primary forms of government.

Further complicating our understanding of the institution of piracy are the constant changes in its demographics, makeup and operation. The ways of ancient pirates differed greatly from those of later ages, but they had several things in common. Even in the earliest times, pirates forced an increased use of technology by governments, from oar-powered vessels to the increased use of sails and, during the Florida-based Mosquito fleet eradication of pirates in 1822, the use of steam-powered ships. Now our many advances in technology are needed to combat current piracy that often also uses improved techniques. Even our modern form of insurance can be traced back to the method of underwriting shipping at Lloyd's of London (Lloyd's Coffee House). Insurance was actually developed there to protect ship owners from severe weather and pirating of their vessels.

It was typical for pirates to recruit and even kidnap individuals who had needed skills or talents. Doctors especially were the most desirable captives for pirates, and they might well earn far more than law-abiding physicians on land. In addition, musicians, master carpenters, navigators and those with technical skills were also pressed into service. They were given full shares

(or greater) in payment, and often the financial reward made many return for future cruises of their own accord. The lure of quick wealth also caused other normally conventional people to voluntarily join the crew of a pirate or privateer ship.

The pirates, particularly in later years, believed in equal rights, and many suggest that piracy and attacks on slave ships helped to bring an end to the slave trade. At any given time in history, between 30 and 50 percent of pirates were black men and women. We shall read about some of the most famous who operated in south Florida waters.

In a day when females, like slaves, were considered to be property, some famous pirates were women. Grace O'Malley, or Granuaile, the Irish pirate, was an influential figure. Zheng Yi Sao, or Ching Shih, was the Chinese ruler of the largest navy in the world at its time, the Red fleet, with more than one thousand ships. Anne Bonny was born in Ireland but lived in Charleston, South Carolina, and both she and Mary Read were noteworthy female pirates whom we will focus on later in the book.

In fact, a pirate's life, unlike the images from writings and folklore, was a hard, rough life. Pirates typically traded a long life for short-term freedom and a chance at riches. Remarkably, the unidentified skeletons and bones of at least 103 pirates allegedly were used to form the base of a 1900s national landmark street, McGregor Boulevard, in Fort Myers, Florida, and today those unclaimed, shattered bones may well provide an exclamation point to the life of most pirates.

So, let us chart our course for the sea stories in this book and learn about a few of the many pirates who plied the waters off the coast of Florida and the Florida Keys.

Treasure Fleets Bring Pirates to South Florida

Piracy is an institution driven by economics and takes place in areas where there is the potential of quick wealth. Pirates settled along the Florida Keys and southeast coast of Florida because, for many centuries, most of the gold and silver in the world was shipped within a very few miles of the Florida coastline. In addition to the mineral riches, and thanks to the Spanish Manila Galleon route, spices, silk and other exotic goods from the Far East were also shipped along these same passages.

After the voyage of Christopher Columbus to the New World in 1492, Spain was arguably the most powerful nation on earth. A desire to find gold and silver was motivation for Spain to explore and settle the Americas since Spain had little industry of its own. Soon, a lucrative round-trip pattern developed, whereby Spanish ships brought goods and settlers from the mother country and took back gold and silver on the return trip. Without competition, Spain became the foremost supplier of precious metals in the world.

This exclusive trading agreement soon became an obvious irritant to the other European countries, and in France and England privateers were sent out to claim some of the treasure. The pirates and privateers of other nations soon followed.

In 1522, the year when the French privateer Jean Fleury captured seven Spanish vessels, Spain sent warships into the Atlantic to escort its merchant ships into safe waters. As the privateer and pirate attacks continued into 1537, Spain dispatched heavily armed ships all the way west to the

Caribbean to protect the treasure ships en route to their homeport. This is generally considered to be the first treasure fleet.

Francois Le Clerc, also named "Wooden Leg," was a formidable privateer of this time. He actually had a peg leg and became a part of pirate lore. As attacks by French privateers operating along the Florida coast continued, the Spanish government strengthened the protection of its treasure fleet with increased armed escort ships across the Atlantic. These well-guarded and escorted convoys of treasure fleets were called *flotas*.

King Philip II of Spain, who ruled in the last half of the sixteenth century, relied on the

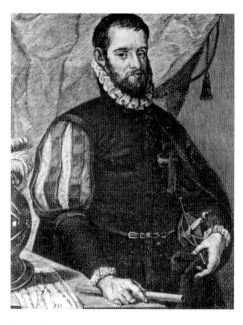

Pedro Menendez de Aviles, developer of the treasure fleet. *PD-Art.*

recommendation of one of his most trusted advisers and an experienced admiral in the navy, Pedro Menendez de Aviles, to establish five treasure fleets and sail two Atlantic sea lanes.

The highly successful Spanish *flota* system was headquartered in Seville in the south of Spain, and from there, the Casa de Contratacion (Council of the Indies) supervised its entire operation. This included the ships, men and armament and is often thought to be one of the most efficient government-run projects since the days of the Roman empire. The Spanish leadership was entitled to a 20 percent tax on all cargo carried in the fleets to and from the New World and Spain. This tax was called the quinto real, or royal fifth, and was important income to Spain as it fought nationalistic and religious wars in Europe. Each time Spain became embroiled in a conflict, piracy and privateering in the Caribbean increased dramatically. The Spanish government came to rely on these annual treasure-laden *flotas* to remain solvent. Thus, defending against pirates and privateers, as well as hoping for good sailing weather, became very important to the Spanish Crown in Madrid.

The yearly trip west from Spain took settlers, troops and manufactured and general goods to the New World via the trade route that sailed south

of the Leeward Islands and Puerto Rico. The westbound cargoes, though valuable and profitable, were seen by many as really being ballast for the fleet. Clearly, its true purpose was to transport precious metals and other valuables along the coast of Florida back to Europe.

When the fleet from Spain reached the Caribbean, the *flota* split into three groups. The Tierra Firme fleet went to Porto Bello in Panama to offload goods and to load Peruvian silver, and then it sailed to Cartagena in Ecuador to pick up gold; lastly, it gathered emeralds from Colombia and pearls from Venezuela.

The second fleet, the New Spain fleet, sailed on to Vera Cruz, where it was loaded with gold and silver from Mexico. The New Spain fleet also took on silks, porcelain and spices from China at Vera Cruz.

The third group of ships was the Honduras fleet, and it called on the historic city of Trujillo to collect a rare and expensive indigo dye.

These three fleets then reunited in Havana, Cuba, where they formed one large unit and sailed along the Florida coast on their way back to Spain, laden with treasures of agricultural goods, lumber, gold, silver, gems, pearls, spices, sugar, tobacco, silk and other luxurious and exotic items.

Adding to these three Atlantic fleets were two more units in the Pacific Ocean. The Manila fleet sailed from the Philippines with Chinese cargo to Acapulco in Mexico. The goods were then transported overland from Acapulco to Vera Cruz in the east, with many land-based pirate attacks occurring on this overland route.

And the fifth fleet, named for the South Seas, ferried Peruvian silver up the eastern Pacific Ocean to Panama. There the silver was loaded onto mules and carried overland to Porto Bello, where it was stowed on the Tierra Firme fleet. This caravan train was known as the Silver Train.

Although the treasure fleet *flotas* were controlled by the Casa de Contratacion, all but a few of the ships that made up the convoys belonged to Spanish merchants, who paid the 20 percent tax to trade

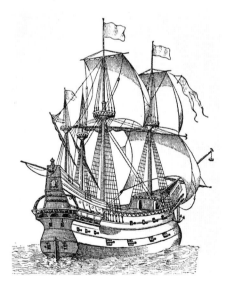

A Spanish galleon, the backbone of the treasure fleet. *Florida Archives.*

with the New World. They were protected by armed royal naval vessels, operated by the Casa on behalf of the king of Spain.

By the mid-sixteenth century, the Spanish royal navy developed a special type of multipurpose vessel to serve as treasure fleet guardian. The Spanish galleon combined the cargo capacity of a large merchantman with the armament of a powerful warship. The galleon had a tall superstructure, with a pronounced forecastle and sterncastle. In later years, it served mainly as a warship.

Although ships from other countries and pirate craft of the day were more maneuverable, the sight of Spanish galleons as part of an organized convoy deterred potential attackers. The pirates often shadowed or followed the treasure fleet, as it was safer to wait for a lagging ship to become a straggler from the convoy than to consider attacking the well-guarded *flota* as a whole.

After loading their precious cargoes, the three Caribbean fleets would rendezvous in Havana to form the treasure fleet, sometimes called the Plate fleet, to sail back to Spain. The convoy would sail out into the Yucatan channel and catch the prevailing winds back to Europe, taking it along the south Florida coastline.

In September 1622, a Spanish treasure fleet of twenty-eight ships left Havana, Cuba. During the night, a hurricane strengthened and began battering the convoy. The ships tried to escape into the open waters of the Gulf of Mexico, where they could ride out the storm. Although a majority of the boats made it into the gulf, eight of them failed to pass over dangerous reefs in the Florida Keys.

Two of these ships were carrying the heaviest load of treasure in the fleet. The Spanish galleons *Nuestra Senora de Atocha* and the *Santa Margarita* struck the reefs, with the *Atocha* sinking almost immediately. The *Santa Margarita* made it over the reef but ran aground on a sandbank two miles from the *Atocha*. Only five survivors of the *Atocha* were found, while a larger number of sailors from the *Santa Margarita* were saved. The remaining treasure fleet ships began salvaging the *Santa Margarita* almost immediately, but the currents and the sand soon buried the ship. The *Santa Margarita* lay undiscovered until 1980, and the *Nuestra Senora de Atocha* was not found until July 1985.

The value of the silver, coins and other items of cargo make the *Atocha* shipwreck the most precious shipwreck ever found. Its total value exceeded $400 million in modern currency. A large portion of the items recovered in this treasure fleet wreck can be seen at the Mel Fisher Maritime Museum in Key West, Florida.

The wreck of the 1715 fleet was the largest maritime disaster in Spain's history, with more than one thousand sailors drowned. This was a convoy of only twelve ships that left Havana on July 25, 1715, bound for Seville, Spain. On July 31, while in the confined waters between Florida and the Bahamas, the fleet was struck by a severe hurricane. As the ships sought safe waters, eleven of them were wrecked along Florida's beaches from Sebastian Inlet to the present-day city of Fort Pierce. The only ship to survive was an accompanying French ship, the *Grifon*. The convoy was carrying an estimated 10 million pesos and other treasures. The Spanish did manage to salvage and recover some of the treasure, thanks to the efforts of the Spanish viceroy in Havana, who sent a salvage crew and sixty soldiers to protect them. The Spanish also employed local Indians, who dove on the wrecks, bringing a large amount of the ship's treasures to the surface. As these valuables were recovered, the salvage was carried to a camp on the beach.

The pirates, who often shadowed the treasure fleets, observed the salvage operation, and word also reached Henry Jennings, a well-respected Englishman and captain of an English ship, the *Bathsheba*. His ship was commissioned to hunt pirates, and like many seafarers of his day, Jennings had experience both as a pirate and a privateer.

Tempted by the news of the 1715 treasure fleet wrecked on the east coast of Florida, Jennings apparently decided to give up being a respectable British sea captain and return to piracy. He found the treasures being accumulated at the Spanish salvage camp to be a golden opportunity, and so he gathered a fleet of two ships and three sloops, as well as a crew of about three hundred men, by some accounts.

Jennings attacked the Spanish salvage camp and drove off the soldiers guarding it. His crew of pirates then loaded an estimated 350,000 pesos and other booty and vowed to return later for the remainder. While en route to Jamaica, where he anticipated a warm welcome, Jennings's pirates captured another Spanish ship and an additional booty estimated to be 60,000 pesos.

Meanwhile, the Jamaican governor had declared Jennings's raid an act of piracy, and Jennings decided to sail instead to New Providence in the Bahamas. His ships were then based out of Nassau for a short time, and he was referred to as the unofficial mayor of the growing pirate community in the Bahamas.

In 1718, following the issuing of an amnesty for pirates from the new governor of the Bahamas, Woodes Rogers, Henry Jennings retired as a wealthy plantation owner in Bermuda. He was one of the few pirates who left the trade and lived a fine life afterward.

The overall success of the Spanish treasure fleets unknowingly brought on a new era in both trade and demographics in the New World and in the waters surrounding Florida.

The scourge of European diseases had arrived, beginning with the voyages of Columbus, and they had a significant and negative impact on the local native peoples. These were the individuals who provided most of the labor for the Spanish empire in the New Spain regions. The native Indian population of New Spain fell by as much as 90 percent from its original numbers during the sixteenth century. The loss of this indigenous group led Spain to increasingly rely on African slave labor to run Spanish America's colonies, plantations and mines.

As slaves were introduced and colonization increased, a whole new dimension for piracy around Florida was created.

Triangular Trade and the Golden Age of Piracy

Spain, during the sixteenth century, brought slaves and indentured servants to areas of the Caribbean to expand the mother country's power base to supplement its workforce of native Indians. Many of these native people had died as a result of the diseases the Spanish also brought. It was the English, however, who established slavery as a capitalistic enterprise and were largely responsible for bringing the African slave trade to the New World.

In the 1600s and throughout the next two centuries, nearly 12 million Africans were kidnapped and shipped to the New World to perform grueling labor under deplorable conditions. African kings and warlords sold the people they enslaved to Europeans, who manned forts along the coast of Africa. After the captives were taken to these coastal forts, they were held for sale.

Sir John Hawkins is considered the pioneer of British slave commerce and pioneer of the triangular trade system. Eventually, he became an Elizabethan hero in England as a shipbuilder, naval administrator and commander, as well as a successful merchant. As navigator and architect of the British navy, he was instrumental in the defeat of the Spanish Armada in 1588, for which he was knighted.

Forming a syndicate of wealthy merchants to invest in the slave trade, Hawkins set sail for the Caribbean in 1555 with three ships. After hijacking a Portuguese slave ship containing 301 captives, he sailed on to the Caribbean. Although two of his ships were seized by the Spanish, he continued on to

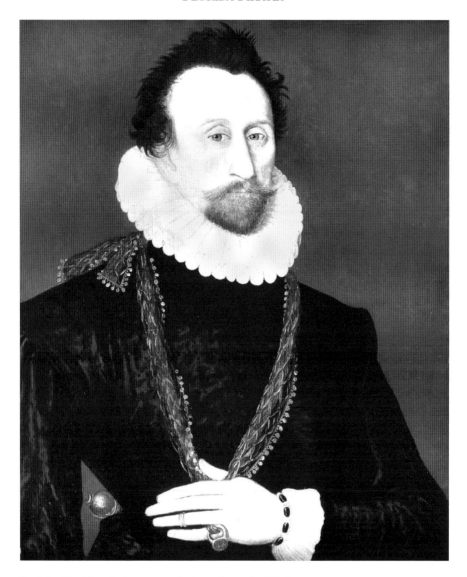

Sir John Hawkins, the innovator of triangular trade. *PD-Art.*

Santo Domingo, where he sold the slaves and made a sizable profit for his English investors. Both the Portuguese and the Spanish considered Hawkins a pirate. His daring actions influenced Spain to ban English ships from trading in their West Indies colonies.

From 1563 through 1579, John Hawkins created the triangular trade. His well-documented slave-raiding voyages and written details are included in *An Alliance to Raid for Slaves.*

The need for colonial manpower was conveniently filled by the use of slaves, as the English employed a plantation system to produce cotton, tobacco, lumber, fish, sugar and alcohol products in southern North America and the Caribbean. These products were to be traded for needed manufactured goods from Europe.

The triangular trade involved ships leaving England loaded with cargo that they could trade for slaves on the West African coast. These cargoes included beads, glass, pewter ware or even pig iron.

The second leg of the triangular trade was known as the Middle Passage. There, in African ports, the ships were loaded with slaves, who were shackled and chained below decks with limited food and water and unsanitary conditions; they were then exported from their home territories to the Americas. The Middle Passage of the journey was one of the most brutal aspects of slavery, and an estimated 15 percent of the Africans died from the conditions.

The brutality of the slave ships was not just aimed at the slaves—many slave ship captains visited even greater agony upon their crew members. This harsh treatment often resulted in a crew mortality rate as high as 30 percent on a single voyage. The theory behind such inhumanity was that the loss of a slave was the loss of potential profit, but every sailor who died was a savings in wages. Under these conditions, many sailors chose piracy versus the often violent, short and miserable life of a slaver crewman.

The third part of the triangular trade occurred after the slaves had been sold at auction in the Americas. The ship would then load a cargo of sugar, cotton, tobacco, rum or other commodity and sail home to England. The triangular trade pioneered by Sir John Hawkins was profitable at all stops and lasted for more than 250 years. As the colonies and settlements along the Atlantic Coast developed, variations of this trade provided products from New England and other areas a market in the West Indies trade.

The end of Spanish wars with other European countries created economic changes that encouraged the slave trade to exist unabated for so many years. With plentiful slave labor and the demobilization of the navies of most countries, the result was the unemployment of thousands of sailors. These factors, in turn, allowed the slave ship owners to lower the seamen's wages, amid worsening onboard conditions, all to achieve greater profits.

Initially, sailors fought the decline of their profession as seamen. They participated in work stoppages and sabotage in their battles with the ship owners and captains. In fact, the concept of the strike, or work stoppage

by employees, was formed in 1768 in London, when sailors went from ship to ship cutting down, or "striking," the sails to prevent the slavers from leaving port.

These conditions influenced sailors and former navy officers to live outside the law. They gravitated toward a presumed chance of freedom and riches and caused the ranks of pirates to swell during the Golden Age of piracy. It lasted from about 1650 until 1730 and was centered in the Caribbean and Florida waters.

One example of a typical slave ship was the *Henrietta Marie*, which plied south Florida waters and sank thirty-six miles west of present-day Key West. The vessel was probably built in France in the 1690s but had been captured by the English navy during the Nine Years' War (War of the Grand Alliance) and sold to private ship owners to serve the triangle trade. In 1697, it was loaded with trade goods to be exchanged for slaves in West Africa. The *Henrietta Marie* made a profitable voyage that brought it back home to England in 1698.

The *Henrietta Marie* became known as a "ten per center," which meant that 10 percent of the profits from its voyage was to be paid to the Royal African Company, which had a monopoly on African trade at the time. In exchange for the 10 percent, the ship was allowed to use the Royal African Company's ports and facilities in Africa.

After delivering a cargo of trade goods at West Africa, which were exchanged for a number of Igbo captives, the *Henrietta Marie* transported about 250 slaves to the island of Jamaica, where they were sold. The ship then took on a cargo of sugar, indigo, cotton and ginger for the return to England. The *Henrietta Marie* then set sail around the western shoreline of Cuba to reach the westerly winds that would take it past Florida, but just south of the Marquesas Keys, the ship disappeared in a probable hurricane. There were no survivors.

In 1972, the *Henrietta Marie* was discovered, providing physical proof of the inhumanity of the slave trade. The iron leg shackles worn throughout the voyage by the slaves were recovered from the ship and included sizes for adult men, grown women and children. Such was the indiscriminate nature of the slaver.

Ironically, the triangular trade and other forms of slave trade may actually have contributed to the promotion of some black individuals to positions of equality, at least among the brothers of the pirate crews.

As we have read, piracy and the slave trade were connected from the beginning. The vast amount of money gained by using slave labor and profits

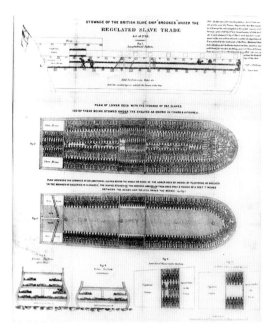

Aboard a slave ship during the era of triangular trade. *Florida Archives.*

from the triangular trade meant that investors began constructing sleek, fast ships capable of carrying large amounts of cargo, human as well as precious metals and spices. The pirates of the Caribbean and the waters off the Florida coast coveted these ships and captured them to convert to their own use.

Capture of slave ships early in the history of the triangular trade bore different results. Some pirate crews accepted the slaves as fellow sailors and taught them to become seamen, but in most instances pirates simply captured the slaves as servants to themselves. The greediest of them typically sold the slaves to plantations and kept the money.

However, as time went on, more slaves captured by the pirates took up the lifestyle themselves to preserve their freedom and survival. This was necessary, because if these Africans were recaptured in any other setting, they most likely would have been sold or turned in for reward money offered by the slave owners.

Becoming a pirate provided some alternatives—existence in a democratic setting (typically) and voting on all major decisions affecting them individually, regardless of race or national origin. The pirates elected their leaders, divided their spoils fairly, held trials or "parleys" among their peers and even established an early form of workers' compensation by establishing amounts to be paid to injured crewmen and to the families of dead pirates.

We will never definitely know the background of pirate crews. We do know that black former slaves made up a considerable portion of the crews for many years. One of the most famous pirates, Blackbeard, headed a band in which nearly half were black pirates. Pirates generally showed little of the racial prejudice that was growing at that time to justify the triangular trade, and just as well—the crews always needed competent, hardworking

31

deckhands and sailors, regardless of nationality. Many pirates even called themselves "maroons," copying the name adopted by the escaped Jamaican slave gangs of the day.

Because the popular thinking of the day intended to show Africans as less than human to justify the slavery enterprise, the historical writers during that period were less than truthful. One example was the famous Dutch pirate Laurens de Graaf, who plied the waters around Florida and the Caribbean islands. He led a fleet of more than two thousand men that attacked the Spanish, causing the nation great concern. He was granted a pardon by the French and retired to become one of the founders of Biloxi, Mississippi. Many history books describe De Graaf as tall, blond-haired, blue-eyed and white, but others claim that, in reality, he was a black escaped slave who attained historic status.

Although the transatlantic slave trade was declared illegal in 1808, it continued unabated in the waters off the Florida Keys and in the Gulf of Mexico. In 1820, a United States government declaration was issued to suppress this established commerce in human beings. It stated that Americans taking part in the slave trade would be prosecuted as pirates. During that time, however, Americans based in Florida could not be prosecuted since the United States had no written statutes regarding piracy in a territory.

To give teeth to the enforcement, the West Coast Indies squadron was formed to eliminate pirates and slavers from the coasts of Florida and the Caribbean. March 29, 1825, is the date often cited as when piracy was eliminated, according to the United States government. This declaration was made to ensure that the Monroe Doctrine of the United States could be carried out throughout the Caribbean.

What was unforeseen was the response of the United State Navy, whose actions drove many pirates from the sea to the shoreline to later become wreckers.

After the first declared end of slavery and piracy by the United States in 1825, many slave ships and pirate craft still sailed the Straits of Florida in the Florida Keys. The *Guerrero*, a Spanish slaver, was chased onto Carysfort Reef by the British Schooner *Nimble* on December 20, 1827. Shockingly, on board were 561 slaves and a crew of 90, making this one of the largest slavers still operating.

On March 3, 1859, the *Martha Regan*, a 250-ton ship, was intentionally wrecked on the Marquesas Shoal to destroy evidence of a successful slave transport. The officers and crew were captured by the schooner *Hermitage* and taken to Key West.

And even later, in 1860, the U.S. Navy captured three ships and 1,432 Africans, whom they took to Key West and eventually sent to Africa, where freed slaves had founded the nation of Liberia.

During the American Civil War, despite Union effort to squeeze the Confederates by blockades, many Southern and English privateers operated in the waters around Florida. Piracy, slavery and human trafficking continue there to this day.

During the Golden Age of piracy, we need to mention that there were many more noteworthy pirates plying the waters around Florida at that time whose names evoke the mystique of the seas.

Two Black Caesars

During the seventeenth and eighteenth centuries, about 30 percent of the sailors were of African descent. They proved to be very capable in seafaring occupations and were sought as cooks, musicians and skilled sailors. It is estimated that nearly 50 percent of Caribbean pirates were black during the Golden Age of piracy. At sea, as pirates or privateers, they were often treated as equals; otherwise, they had few career choices and often had to work as slaves on land.

Two African pirates named Black Caesar allegedly sailed the waters of the Florida Keys and the Atlantic Ocean and may have spent time on Sanibel and Captiva Islands in the Gulf of Mexico, also referred to as the "Mangrove Coast." We use "allegedly" because at least one and perhaps both Black Caesars may be more myth than fact. Coincidently, besides both claiming the same pirate name, they came from similar backgrounds before becoming pirate captains. Their careers as pirates were about one hundred years apart, and it is probable that the latter Black Caesar adopted his pirate name from the feared and successful earlier man. Reputation was important to a pirate, and the worse one's reputation was, the better chance of future conquests without having to engage in battle. Both Black Caesars were implicated in legends that describe the imprisonment of women. These captives were supposedly held for ransom in the Florida Keys and at Captiva Island on the western side of the Gulf of Mexico.

The first Black Caesar, born in the 1600s, was a prominent African chief known for his intelligence, great size and physical strength. It is thought that

he was educated by the Spanish slave traders with whom he worked. After he was taught about the ancient Romans, he took the Latin name of Caesar, as he viewed himself also a royal leader.

While still in Africa, Caesar and his tribe became wealthy and powerful by providing many slaves to the traders. Black Caesar was aware of the great profits the slavers were earning, and eventually he became an annoyance to them by demanding more money and treasure.

One devious Spanish slave ship captain, after displaying his gold watch and other jewelry, enticed Black Caesar and twenty of his warriors aboard his ship, where he claimed to have more treasures too heavy and numerous to bring ashore. Once aboard, the captain continued to tempt the Africans with food, alcohol, silk scarves and jewelry. The ship's musicians demonstrated their instruments and entertained Caesar's entourage, and as the festivities continued, the captain had his men quietly raise the anchor. The slaver began to slowly drift away from shore before Caesar sensed what was happening and started to resist. A group of well-armed Spanish sailors, using swords and holding pistols, succeeded in capturing the Africans and placed them in irons beneath the deck. The ship, with Black Caesar and his men imprisoned below deck, set sail for the Spanish Main. The Spanish captain intended to sell Caesar and his men as slaves and earn money from the sale, therefore eliminating the potential for rebellion and business disruption that might transpire if Caesar remained free.

During the lengthy voyage, Black Caesar would not eat or drink. He refused to accept the fact that he had been captured, and he distrusted and despised all the crew. Perhaps it was through his great thirst that Black Caesar finally befriended one sailor, from whom he would accept food and water. The captain permitted this alliance since it was in the best financial interest of his investors to offer an intelligent, strong former chief on the slave block.

As the ship finally approached the southeast coast of Florida, the scourge of all shipping, a severe hurricane, approached the slave ship and threatened to wreck it on the reefs. Black Caesar's befriended Spanish sailor went below deck to free Black Caesar from his irons before the ship was destroyed. Most sources report that the two men escaped in a longboat with supplies and ammunition, leaving the others to die. Some claim that they confronted the captain and crew with weapons and demanded the longboat. Other stories relate how Caesar and his friend escaped from the sinking ship and attached themselves to its remnants, floating to what is now Elliott Key in the upper Florida Keys. The strong winds and relentless

surf pushed them to shore, where they waited until the hurricane blew over, the only two survivors from the ill-fated slave ship.

Regardless of which story is believed, the sailor and Black Caesar supposedly used Caesar's Rock, a small rock island between Elliott Key and Old Rhodes Key, as one of their lairs. The creek that separates the three islands and provides a channel to the Atlantic Ocean became known as Caesar's Creek. While staying there, the two outcasts supposedly anchored their confiscated longboat to the limestone rock. They avoided detection by partially capsizing the boat, lowering the mast and camouflaging it when it was not being used in order to ambush boats that might come to anchor in the calm waters. After operating from this area for a time, the two survivors established another camp on Elliott Key that provided more hospitable conditions.

For the next few years, Black Caesar and his friend would row the old longboat into the shipping lane when they spotted a ship and pose as distressed survivors of an apparent shipwreck. When the vessel stopped to offer rescue or assistance, the two pirates would draw their guns and demand supplies, food, ammunition and other treasures that the ship might be carrying. Some claim that over a period of time, the two pirates amassed a formidable treasure, which they buried on Elliott Key. These rumors persist today, even though pirates tended to spend their riches instead of hoarding them. Eventually, on one of their attacks, the Spanish sailor kidnapped a beautiful young woman and brought her to live on Elliott Key. Black Caesar, attracted to the woman, challenged his best friend to a duel, killing him and taking the woman as his own. This act foreshadowed Black Caesar's later habit of seizing and collecting women from passing ships.

With the death of his companion, Black Caesar was forced to change his operation and recruit more pirates and former slaves. Soon he had enough ships and power to attack shipping on the open seas of the Atlantic and in the Straits of Florida. The raiders' location on Elliott Key offered them an advantage in avoiding capture as they could sail into Caesar's Creek and the other numerous inlets. After Black Caesar's renegade band established a pirate community in the area of Elliott Key, it experienced a very successful period during which merchantmen and various small boats were attacked and captured. The legend tells us that these early pirates, operating on Florida's southeastern coast, brought their human prey and captured vessels back to Elliott Key and Caesar's Rock. There, using a metal ring embedded in the rock, they would tie the ships to the rock and either sink them or turn them over to effectively conceal them from a passing patrol or navy ships.

Later the bandits would cut the ropes, pump the water out of the ships and use them to continue their pirating.

Black Caesar established a prison on Elliott Key. Unlike many pirates, who saw ransom value in keeping prisoners healthy for a monetary return, he was brutal to his captives. Black Caesar is one of a number of pirates in history given credit for first using the phrase, "Dead men tell no tales."

Black Caesar enjoyed women, and some historians estimate that he had more than one hundred women in his harem at the prison camp on Elliott Key. The women were taken from passing ships and initially were not held for ransom but rather only for his pleasure. When leaving the island on his forays, Caesar made no provisions for his prisoners, including his women or the children who had been born. Many of the captives died of starvation during these absences, but it is believed that some of the children escaped captivity to exist on berries and shellfish. They were said to have formed their own language and customs, which gave credence to the native superstition that the island was haunted.

As his pirate empire grew, one story suggests that Black Caesar decided to expand his pirating base. Accordingly, he moved his harem out of harm's way and away from threats from his own pirates to the current islands of Sanibel and Captiva off the southwest coast of Florida. Having learned by now from other pirates that ransom income could be earned from holding captives hostage, he built a village for his women on Captiva Island. They resided there, cared for and safe, until claimed. He also established a base on neighboring Sanibel Island and traded actively with the local Calusa Indians. These profitable colonies were isolated not only from trading ships on the well-traveled routes of the eastern coast but also from the threat of other pirates or navies protecting those routes.

Sometime in the early 1700s, while at his base at Elliott Key, Black Caesar is said to have joined forces with the notorious Blackbeard. There are two theories as to the reason Black Caesar left his pirating sites. One is that the opportunities to plunder around his eastern area of operation were diminishing and becoming more dangerous. This was due to increased navy operations by various countries and the increase in the number of privateers hired by traders to hunt pirates in response to the great losses suffered by businessmen. The other theory is that Black Caesar simply wanted to serve with the notorious pirate captain whom he had long admired.

Regardless of the reason, for nearly a decade, Black Caesar was an important member and officer of the crew of Blackbeard's ship, *Queen Anne's Revenge*, as they plundered ships and cities along the east coast

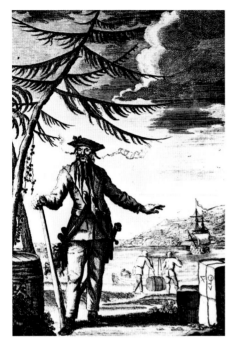

Blackbeard, the most famous pirate captain. *Florida Archives.*

of the English colonies. Like Blackbeard, Black Caesar was respected for his ruthlessness by many on board the ship.

In November 1718, Lieutenant Robert Maynard of the British Royal Navy and his men attacked Blackbeard's pirates near Ocracoke Island off the Carolina coast. Blackbeard, knowing that Black Caesar was fearless, is said to have ordered him below deck to the ship's powder room, where the explosives were kept. Caesar had orders to light a fuse and blow up the ship if the Royal Navy sailors were successful in boarding the *Queen Anne's Revenge*. He was about to light the match to a trail of gunpowder on the deck when two prisoners, whom Blackbeard had stowed below deck before Maynard's attack, freed themselves and overcame Black Caesar, preventing him from lighting the deadly fuse.

Black Caesar was taken to the colony of Virginia and tried in Williamsburg. He was hanged after being found guilty. It was noted that he refused to testify and give any evidence against his shipmates.

The Black Caesar tales in Florida did not end with the hanging in Williamsburg. Almost one hundred years later, another Black Caesar allegedly appeared in the Florida waters. The second Black Caesar was supposedly one of the most vicious pirates to sail the waters off Florida.

Henri Caesar's exact date of birth is not known, but he was supposedly born in the last half of the eighteenth century on the French island of Hispaniola, which was then known as Saint-Dominigue. He was the son of a female slave owned by Monsieur Arnaut, a wealthy planter with a large plantation. Henri's father was a Frenchman of some reputation, according to one legend. This multiracial birth was not unusual at that time, as the French-controlled western part of Hispaniola, later known as Haiti, included 30,000 to 40,000 whites and an almost equal number of mulatto, or "free

coloured," people, who were descendants of slave women and white men. However, the overwhelming portion of the population, 480,000—men, women and children—were slaves.

There were two classes of slaves, and this led to many conflicts. The first group were known as "creoles." They had been born in the Caribbean islands, primarily Saint-Dominigue, and typically worked as domestic servants. They were also taught trades in construction or sugar manufacture and were taught to ride horses and care for the animals of the plantations. They were often given authority over the slave gangs that toiled in the sugar fields.

The second group of slaves were those born in Africa and used as field hands or given physically demanding tasks under the repressive discipline of their masters. The attitude of the slave owners at that time reflected the philosophy that it was more profitable to work the African slaves to death and import new slaves from Africa than to invest larger sums on maintaining their health and well-being. Though the French government attempted, in 1685, to curtail individual planters from their cruel practices through a measure known as the Code Noir, the atrocities still continued.

At a young age, Henri Caesar, a dark-skinned mulatto, became a houseboy and enjoyed a good life. He was intelligent and learned a great deal from overhearing his master's conversations. Other household members delighted in teaching Henri how to read and write, and he developed a desire not only to be a "free coloured" but also to become a gentleman.

Unfortunately for Henri Caesar, by the age of sixteen he had grown to be over six feet tall, and he towered over everyone else in the house. He was powerfully built as well. This is when Henri began to question the policies of the slave system; disruptions were created in the operations within the house and among the rest of the domestic staff.

Master Arnaut removed him from the household duties and had him placed in the plantation lumberyard, where his strength could be better utilized. Henri Caesar resented this transfer, which resulted in a drastic decline in his standard of living. Worse yet, the lumberyard overseer was a cruel Frenchman who delighted in whipping the African slaves and drawing blood from them as they used the two-man saws to cut mahogany logs. They were forced to toil six days a week, enduring twelve-hour days. Hatred of this man became paramount in the young Caesar's mind.

In 1791, Caesar took part in a massive slave revolt led by Boukman Dutty and Toussaint Louverture. He and a band of armed renegades captured the

plantation, and Henri took great joy in cutting his former overseer to pieces with the very saw he was forced to use during his servitude. Caesar escaped to the jungle, where he spent the following nine years as a rebellion leader attacking French patrols and forts.

In 1804, the western part of Saint-Dominigue became the second nation in the Western Hemisphere to become independent after the United States set an example. The successful Haitian revolution was one of the factors causing the French leader, Napoleon, to abandon his dream of expanding French holdings in North America. This, in turn, resulted in the Louisiana Purchase, a massive tract of land in North America being sold by France to the United States for $3 million.

According to one source, Henri Caesar was appointed to a leadership position in Toussaint Louverture's new Haitian government. Before a year had passed, Caesar was disgusted with the lack of planning and government by the revolution leaders. In 1805, he and his men spotted a Spanish merchantman ship becalmed in the waters. They stole a small boat and captured the ship in the darkness. The crew was not harmed until he and his men learned how to sail the vessel; then he had the crew members killed one at a time.

Henri Caesar then turned to pirating out of Port de Paix on the northern coast of Haiti. After capturing ships off Cuba and the Bahamas, Caesar realized that relocating to Elliott Key in the northern Florida Keys would give his pirate gang an excellent location to attack small merchant ships off the Cuban coast and the Bahamas channel. This Black Caesar, like the first Caesar, was successful for the next decade. He began to refer to himself as Caesar le Grand, or Caesar the Great.

However, following the War of 1812 and the purchase of Florida by the United States, Henri Caesar was forced to abandon his lucrative base on Elliott Key and move northwestward into the Gulf of Mexico. He is said to have established camps on most of the now populated islands off the southwest Florida coast, including Marco Island, Black Island, Sanibel Island, Captiva Island and Pine Island. These camps gave impetus to the many false tales of treasure allegedly buried on the islands.

Black Caesar, or Caesar le Grande, formed a settlement on the bay side of Sanibel Island and waged pirate raids against villages and small ships off the coast of Florida and Cuba. During this time, Black Caesar brought prisoners back to the isolated islands, where they were held for ransom, just as his namesake is alleged to have done one hundred years earlier. He is thought to also have placed his female captives on Captiva Island.

The legend of the second Black Caesar includes his overtures to join José Gaspar, known as Gasparilla, whose actual existence is doubted by most historians. Part of this legend includes the fact that Gasparilla never liked Caesar. When some of Black Caesar's men supposedly became drunk and attacked Gasparilla's female captives on Captiva Island, it is said that Gasparilla's pirates drove Black Caesar from Sanibel and Captiva Islands.

President Andrew Jackson ordered an expedition against pirates operating off the Florida coastline in 1828. Nearing the end of his vicious life, Black Caesar began drinking heavily and suffered the lapses of judgment common to such actions.

There are various reports of Black Caesar's demise. One of the most popular is that he was captured by a Spanish privateer off the coast of Cuba in 1829 and that he died shortly after his capture while being held prisoner.

The other tale is that Henri Caesar was captured in southwest Florida and taken to Key West, where he was put on trial and found guilty. Because of his reputation and the cruelty that he had shown his victims, Henri Caesar was given a most unique sentence. The widow of a preacher whose eyes had been burned out under the torture of Black Caesar was given the opportunity to retaliate. Caesar the Great was tied to a tree, and the widow lit a fire at his feet. He was thus burned alive.

Golden Age Pirates of Florida

B efore we look at the Golden Age of piracy, from about 1650 to 1730, we need to know the factors that brought it about.

After seizing and mining the immense treasures of Central America, the Spanish had the difficult task of transporting the riches back to Seville. The strong northeasterly trade winds aided westbound ships from Europe, helping them traverse the Caribbean waters, but they hindered those traveling from the west. The ocean currents abetted the winds. When the westbound Atlantic current reached the coast of Central America, it turned northward to travel between Cuba and the Yucatan Peninsula and into the Gulf of Mexico. From there, the current was forced through the ninety-mile strait between Cuba and Florida, and then the powerful Gulf Stream swept north along the North American coast and back to Europe. The Spanish sailors had to learn not only to take advantage of these winds and currents but also to be wary of hurricanes, uncharted reefs and treacherous sandbars along the coastal regions.

It did not take long for a horde of pirates and privateers to pillage Spanish ships in the waters surrounding Florida. With the trade routes carrying millions of dollars in wealth along the coastline of Florida before beginning the journey west to Spain, it is probable that many famous or infamous pirates sailed in these waters.

It is important to remember that Spain was intent on establishing more mining and agricultural colonies throughout Florida and the Caribbean to enrich the Crown. England, Holland and especially France took a swipe

The Spanish came to Florida to conquer. *Florida Archives.*

at Spanish shipping and wanted to ensure their places in the area as well through colonization of the Caribbean. Therefore, the sparsely settled islands of the Caribbean became not only havens for pirates and privateers taking advantage of Spanish shipping but also centers for renegades and persons of questionable character whom the rulers of European countries had sent to settle the islands.

The term "buccaneer" is derived from the word "boucan," which referred to the cooking device used by the Hispaniola French to produce smoked meat. These men using this method, who lived off the wild herds of cattle in Hispaniola, were often lawless adventurers who originally became known as "boucaniers." The word, soon adopted by the English, became "buccaneer" and became generally used to mean a pirate or privateer based in the West Indies.

The early buccaneers used swift and small, easily maneuverable vessels called sloops. These sloops could sail or be rowed in shallow water and could carry up to fifty men. The preferred weapons of the buccaneers were cannons for the English and small arms and knives for the French.

About 1640, the "Brethren of the Coast" promised to follow a code. The "Custom of the Coast" decreed that the buccaneers would elect their captains. Division of the loot gave extra shares for the captain, owner of the ship and the first pirate to spy a prize. The cabin boys earned only half a share, while some salaries were fixed, such as those of the shipwright and surgeon. They also fixed compensation for those maimed while at sea.

Since the focus of this book is on the relatively few pirates who actually established bases of operation in Florida territory, we feel it necessary to mention the deserving others, as they had a strong influence on the history of piracy in this era.

Three notable buccaneers who operated throughout this area, but concentrated their areas of operations south of Cuba and the Caribbean, were Henry Morgan, L'Ollonais and William Dampier.

Henry Morgan, from England and probably the most successful buccaneer, operated against the Spanish during the period of 1663–70 and was later knighted. He was made governor of Jamaica in 1674.

Possibly the most brutal pirate of the area was Jean-David Naw, known also as L'Ollonais after his birthplace at Les Sables d'Ollonne in France. Many atrocities were attributed to him, especially by the Spanish, whom he hated. He was known to gather Spanish captives and cut the heart from one screaming victim to feed to another.

The English pirate William Dampier is known for publishing three books describing his buccaneer adventures. They have become sources for much of what we know of buccaneers today. It is thought that Dampier's writings and other pirate descriptions included references to the stereotypical parrot often perched on the shoulder of a buccaneer. This was probably the *Amazona vittata*, a parrot native to Hispaniola and known for the bright red shock of feathers at its forehead, the white rings around its eyes and the shimmering blue feathers under its wings. Pirate pets were usually limited to birds or members of the rodent families because of the nature of pirate life on board a ship.

Of the other pirates who operated regularly around the Florida territory, Sir John Hawkins, an Englishman, served as a privateer to Queen Elizabeth I. He was highly regarded by the French because during one of his many adventures, he saved a large number of Frenchmen at Fort Caroline on the St. John's River, then called the River of May.

Sir Francis Drake served under the slaver John Hawkins early in his career. Drake and Hawkins, along with Sir Richard Grenville, attacked Spanish settlements and ships. During this period, the letter of marque was established and granted to privateers. It was a document issued by a monarch, and it essentially gave license to attack and seize the ships of a hostile nation. The English considered this licensed and privately owned naval force serving under their flag as a privateer fleet, but the Spanish felt they were pirates. As a privateer, Drake captured St. Augustine and, two years later, led the English fleet to victory over the Spanish Armada. This granted him knighthood from Queen Elizabeth.

Robert Searles, also known as John Davis, was an English buccaneer who operated as a local pirate in the Florida Straits off the Keys and south Florida. It was not until after he captured a Spanish supply ship from

Havana, Cuba, en route to St. Augustine on the eastern coast of Florida, that Searles decided to sail up the coast of Florida and attack the Spanish city of St. Augustine. A French doctor had been pressed into service on the Spanish vessel, and he related to Searles the vulnerability of the prized settlement. In May 1668, Searles and his pirates attacked and raided the town of St. Augustine. This raid indicated that the Spanish settlements in Florida were indeed vulnerable to conquest. Construction of the Castillo de San Marcos, a Spanish fort in St. Augustine, was begun in 1672 in response to the English threat. Many local pirates continued to attack St. Augustine and the areas surrounding it.

As the English began operating more effectively and started establishing more settlements and trade, their ships were also subject to attack by pirates. Captain Kidd was originally hired and financed by merchants to hunt pirates. His investors sought profit from capturing pirate treasure, as well as eliminating threats to English shipping in the area. Since, as we have read, pirate treasures usually did not exist, Kidd's exploits in this arena were highly unprofitable. Captain Kidd, therefore, became a pirate himself. This did not bring the financial return expected by his sponsors, who eventually had him arrested. He was found guilty and hanged, with his body left to dry out on the execution dock.

Charles Vane is the last of the pirates we will mention in this chapter. He was an English pirate who preyed on English and French shipping during a pirate career that only lasted from 1716 until 1719. Vane was a pirate ship's captain when he was replaced by "Calico Jack" Rackham, to be discussed later.

Charles Vane most likely started his naval career aboard one of Lord Archibald Hamilton's English privateer vessels. He became a pirate in 1716 and served under pirate captain Henry Jennings. In 1715, a hurricane resulted in the

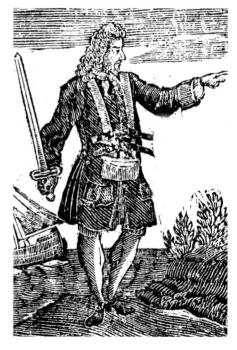

Charles Vane, an early Caribbean pirate. *Florida Archives.*

wreck of the Spanish treasure fleet off the east coast of Florida. Jennings recruited more than three hundred pirates from his center at New Providence, in the Bahama Islands, to raid the Spanish salvage ships that were loading silver from the wreck. They also attacked the landed salvage crews at their encampment and captured the retrieved treasures.

Charles Vane was a vicious man who paid scant attention to the established pirate code. He soon left the more honorable Jennings to strike out on his own. Even within the pirate community, Vane was known for his cruelty toward captured sailors and their vessels. After his first attack as a pirate in his own right, he was reported to the governor of Bermuda for torturing and wantonly killing the Spanish sailors he captured even after promising them mercy. He also cheated his own crew out of their shares of the plunder.

Vane continued to plunder and pillage, each time trading up ships until he commanded a large twelve-gun brigantine that he named *Ranger*. Vane and his pirates were cornered in February 1718, but Vane, aware of the forthcoming royal pardon to all pirates, claimed that he was simply sailing to New Providence to obtain his pardon. Captain Vincent Pearse, commander of the HMS *Phoenix*, issued Vane a pardon, but Charles soon resumed his pirating.

In August 1718, the new governor of New Providence, Woodes Rogers, arrived in Nassau to oversee the royal pardon of pirates. He was accompanied by two English man-of-war ships. While most pirates accepted the enforced pardon, thus closing out the Golden Age of piracy as far as the English were concerned, Charles Vane refused the pardon and attacked Roger's two ships. He repelled the English with a captured French vessel, which he set afire. Vane then escaped on the *Ranger*. As he sailed past Woodes Rogers, he fired the cannons, evaded all the ships in the harbor and escaped.

Charles Vane sailed north to continue his piracy. He had a large crew of pirates and increased his fleet to three vessels. In the fall of 1718, Charles Vane met with Edward Teach, also known as Blackbeard, at a weeklong pirate fest on Ocracoke Island in North Carolina. He then appointed himself captain of the largest of Vane's three vessels, the *Neptune*. On his next voyage, the *Neptune* failed to engage a heavily armed French warship in the Windward Passage. When his displeasured crew considered him to be a coward, they mutinied and recruited "Calico Jack" Rackham, the ship's quartermaster, to become captain. Though initially refusing, Rackham finally agreed, and after a parley on the deck

of the *Neptune*, Charles Vane; one of his consorts, Robert Deal; and fifteen of his loyal sailors were set adrift at sea in an unarmed sloop. Rackham and the remainder of the crew turned south, renamed the ship *Kingston*, and began a new series of pirate raids.

Charles Vane once again plundered ships using stolen arms until he had a fleet of four ships. A hurricane forced the ships apart, and Vane's wrecked on a reef in the Bay of Honduras in February 1719. Vane was one of a very few survivors. He lived, with the help of local Indians, but was recognized and captured by Captain Holford, a former pirate who now commanded an English ship. Knowing Vane and his reputation, he chained Charles and turned him over to the authorities in Jamaica. There he was tried, convicted on March 22, 1720, and hanged on March 29, 1721.

Anne Bonny and "Calico Jack" Rackham

John "Calico Jack" Rackham, Anne Bonny and Mary Read were three eminent eighteenth-century pirates. Their relationship and lawless careers may have been short-lived, but the time they spent on Estero Island and Lover's Key in Florida has forever tied their names to southwest Florida history. On a larger scale, their capture and subsequent trials generated much publicity and discussion worldwide.

Calico Jack Rackham, although a successful small-time pirate captain, is more noted for his colorful calico cotton wardrobe worn in an era when most other affluent pirates dressed in rich silks and velvets. He is also known for the design of his pirate flag, a skull with crossed swords, which has been much emulated. Captain Jack was fond of women, and some reports claim that he kept a harem of mistresses in Cuba. He is most important because of the two distinguished female pirates who served as members of his crew.

John Rackham was born in England. In November 1718, he was the quartermaster, second in command, on the pirate ship *Neptune* under the command of Captain Charles Vane. As mentioned earlier, after engaging a French frigate, Captain Vane ordered the *Neptune* to retreat and withdraw from further fighting. The *Neptune*'s crew objected, voted to make John Rackham the new captain and set Vane adrift. This last gesture, unusually humane in the pirate ranks, shows that Calico Jack Rackham treated his captives with restraint. In fact, there is no recorded instance of Calico Jack using murder or torture during his days at sea.

With his ship, the *Kingston*, Rackham and his crew roamed the Caribbean islands and spent the next several months successfully attacking smaller ships and seizing the booty. They were content to loot safe prizes such as small fishing boats and local trading boats, and Jack even returned at least one vessel to its owner after raiding it.

In early 1719, England and Spain renewed their conflicts. Calico Jack Rackham sailed toward the Bahama Islands in the hopes of being given a pardon or commission from Governor Woodes Rogers, who had been sent there to address the problem of pirates in the Caribbean. En route, a Spanish warship attacked the *Kingston*, and during the ensuing battle, Jack

"Calico Jack" Rackham. *Florida Archives.*

and most of his crew were able to escape the *Kingston* by stealing two fishing vessels. Using these two smaller boats, they captured a Spanish sloop off Cuba and then sailed to New Providence in the Bahamas. Woodes Rogers granted Calico Jack a pardon in May 1719, but fearing that Rackham could not defeat the large Spanish ships, he was not given a privateering license. Rackham therefore had to abandon his life as a pirate for a while.

It was while he was living in New Providence that Rackham first met Anne Bonny, the wife of another lesser-known pirate, James Bonny. Calico Jack was known for his directness, and he persuaded her to leave her husband and run away with him.

Anne Bonny was born about 1700 in County Cork, Ireland. She was the daughter of a prominent lawyer, William Cormac, and a maidservant, Mary (or Peg) Brennan. When William's wife discovered the affair and exposed it publicly, William's legal career plummeted. He tried to pass Anne off as a relative's son by dressing her as a boy for awhile, but finally he, Mary and the baby left in disgrace for North America and settled in Charles Town in the colony of South Carolina. After again trying his luck as a lawyer, William turned instead to the more profitable merchant business, where he amassed a fortune and acquired a large plantation. Meanwhile little Anne's mother, Mary, died, so William raised the child alone.

When Anne reached the age of twelve, she was not only wealthy but also becoming a red-haired beauty. Since she was nearing marriageable age, she began to have numerous suitors. It is significant to note that Anne, in addition to her beauty and riches, had a violent temper. She allegedly stabbed a servant girl with a knife when she was thirteen and severely beat a boy who made advances toward her. In spite of being pursued by many eligible young men of Charles Town, Anne chose to elope with James Bonny, a poor merchant seaman and sometime pirate, who probably hoped for funds from his new father-in-law. Worried that James Bonny would attempt to steal his vast landholdings, William Cormac publicly disowned his daughter and turned her away. According to one story, Anne started a fire on the plantation in retaliation.

The newlyweds sailed to New Providence in the Bahamas. It was there that Anne Bonny, while frequenting the bars and mingling with the pirates, met the bold and colorful Calico Jack Rackham. He soon began to court her and tempt her with jewelry. When her husband, James, found out about their affair, he seized her and dragged her before Governor Woodes Rogers, demanding that she be flogged for deserting him. Anne was considered to be stolen property. As was common for women in that situation, the governor intended to offer her for sale to the highest bidder. Instead, Calico Jack suggested that he would buy Anne directly from her husband. When James Bonny protested and got a court order forbidding Anne and Calico Jack to see each other, Rackham decided that the only way he could have his lover was to kidnap her, steal a ship and return to the pirate life.

Jack and Anne escaped the authorities in New Providence, along with some of Rackham's former pirate crewmen. They stole one of the fastest ships in the harbor, a merchant sloop called the *Curlew*. Anne dressed as a sailor, and under cover of darkness, the *Curlew* was taken from its anchorage. Anne confronted the two men on watch and threatened to blow out their brains with her blunderbuss if they offered any resistance. Unlike Jack Rackham, Anne Bonny was already a forceful, courageous and competent leader.

Jack Rackham and Anne Bonny began the cruise that they called their honeymoon by seizing trading and fishing boats off the coast of Cuba and successfully selling their prizes. Anne was a fierce fighter and was respected by the men on the ship. They were successful in their raiding endeavors, but trouble began when they attacked a Spanish sloop near the current town of Key West in the Florida Keys. In the ensuing battle, their mainmast was shattered by cannons from the sloop, and a new mast had to be found and

raised into place. The attack was abandoned, thus allowing the Spanish sloop to safely sail toward Cuba. A fierce storm created the second disaster when the stricken pirate ship was blown north into the Gulf of Mexico and up the western coast of Florida to Estero Island.

The crew of the *Curlew* guided the ship to safe anchorage in deep water at the southern end of Estero Island, across the bay from the present-day Lover's Key. The crew members then rowed up the Estero River in longboats in search of trees that were of sufficient height to serve as a mast and spars. Although a questionable resource, according to Johnson's *History of Highwaymen and Pyrates*, published in London in 1818, "while the ship's carpenter and crew did labour mightily to refit the vessel, Calico Jack and the woman, Anne Bonny, did make merry for many days on the island where they had a dwelling made of sticks and palms." Considering that nine months after visiting what is now Lover's Key State Park, the couple had their first child, one could say that Lover's Key is appropriately named.

Following the *Curlew*'s repairs in southwest Florida, the pirate couple continued their attacks on Spanish ships near Cuba. Anne was now blossoming with child, and Calico Jack took her to friends in Cuba, where the baby was born. Since Anne loved life as a pirate at sea, she left her firstborn with an older couple and returned to the crew.

After Anne's return, Calico Jack and his band attacked and captured a Dutch merchantman off the Cuban shore. As was the custom, a number of the Dutch crew were forced to sign articles (the pirate contract) or be imprisoned and sold at slave markets. One of these handsome young Dutch boys was neither Dutch nor a boy but rather a woman named Mary Read. Anne was attracted to the young "male" newcomer, spending much time with him, and Calico Jack became jealous. Anne and the newcomer finally confided to Jack the shocking news that the young Dutch boy was really an Englishwoman.

Mary Read was born out of wedlock in England during the late seventeenth century. When her legitimate older brother died, Mary's mother dressed the girl as a boy to fool a doting grandmother who was sending money to support the son. At the age of thirteen, with Mary still dressed as a boy, her mother secured her a position as a footman to a lady. She eventually tired of this life and boldly joined an English navy man-of-war. During the War of Spanish Succession, Mary went to Flanders and fought as a dragoon in the British army, which was allied with the Dutch and Austrian forces. She demonstrated her bravery on numerous occasions but then fell in love with her tent mate, a Flemish soldier who insisted on marrying her.

When the campaign was over, Mary revealed her gender and did become wife of the soldier. They became innkeepers in Holland, where for the first time Mary wore women's clothes. Unfortunately, her husband contracted a fever and died shortly after the marriage, and Mary donned men's clothes again, signed up with a Dutch ship and returned to the sea. When her ship was captured by pirates, she was forced to join them until she took the king's pardon and became a privateer. Eventually, she became one of the crew aboard the Dutch ship that was captured by Calico Jack Rackham and Anne Bonny.

The two female pirates became legendary because of their courage and bravery during the many battles and encounters undertaken by Calico Jack and the pirates on board their pirate ship, the *Revenge*, which had replaced the *Curlew*. Both women were acclaimed for their ability with sword and marlinspike and were often the first to board a prize. There they were said to have exhibited their ample breasts, allowing their captives to realize that they had been captured by women!

Mary Read found a lover on board the *Curlew* in spite of her intimidating appearance and demeanor. She is said to have saved the life of her betrothed when he intended to fight a duel with another pirate. She supposedly began a fight with the adversary and killed him with her sword and pistol before the duel could take place.

On August 22, 1720, Calico Jack's crew successfully stole a twelve-ton sloop, the *William*, from its anchorage in the middle of the channel in New Providence, back in the Bahamas. It is thought that the reason the single-masted sailing vessel was taken by Rackham was because he had a preference for smaller, fast-sailing ships versus the larger, two-masted *Revenge*. In addition, the *William* was well equipped with ammunition and supplies.

The *William* was owned by Captain Jack Ham, who was a close friend of Bahamas governor Woodes Rogers. This relationship caused the theft to be taken more seriously by authorities. Governor Rogers immediately ordered a sloop with forty-five men on board to go after the pirates, and on September 2, he ordered yet another sloop to chase down Calico Jack and the *William*.

In the meantime, Jack, fearing the pursuit, fled south. During this escape, the *William* raided two merchant ships just off the Hispaniola coast for supplies. In mid-October, the pirate ship sacked a schooner near Port Maria on the north coast of Jamaica. In all three encounters, it was again Anne Bonny and Mary Read who led the boarding party. These raids provided the pirates with a large supply of liquor, wine and rum.

Captain Jonathan Barnet, who had received a commission from the governor of Jamaica to capture pirates, commanded a heavily armed privateer sloop. At Negril Point, on the western tip of Jamaica, he spotted the *William* and engaged it in a nighttime sea battle. Calico Jack and the other male crew members had imbibed a large quantity of their captured liquid booty, and to the dismay of Anne Bonny and Mary Read, they were too intoxicated to fight when attacked by the privateer sloop. Anne and Mary fought valiantly against the attackers while Calico Jack and the ten men huddled beneath the deck of the *William*, too drunk to fight.

Anne became so incensed that she fired her pistol at the men below and screamed, "If there's a man among ye, ye'll come out and fight like the men you are thought to be!" Despite the fury and courage of the women, Anne, Mary and the negligent crew were captured. The next morning, they were put ashore at Davis's Cove in Jamaica and escorted across land to the jail in Spanish Town.

Calico Jack and the ten men were tried on November 16, 1720, on four charges of assault and thievery. There were only two witnesses for the prosecution. The pirates pleaded not guilty to the charges, but all were found guilty. Five of the men were hanged the next day at Gallows Point. Calico Jack and the other five men were doomed to hang on November 18.

When Anne Bonny was given one last visit with Jack, she cried out to him, "I am sorry to see you here, Jack, but if you'd have fought like a man you needn't hang like a dog." Calico Jack was hanged the following morning. His body was then placed in an iron cage and suspended from a gibbet near Port Royal in a place now referred to as "Rackham's Cay."

The charges against Anne Bonny and Mary Read were the same as those against the men, but there were more witnesses who confirmed that both women had willingly aided their fellow crew members. Their trial was held on November 28. One of the witnesses, Dorothy Thomas, had been a victim of the *William*'s marauders. In identifying the two women, she referred to the largeness of their breasts. When asked if they had anything to say in their defense, they both said that they had no remarks, and the jury of commissioners found them guilty of piracy and robbery. Anne and Mary waited until they were sentenced by Sir Nicholas, president of the admiralty court, to hang, and then they sprang their surprise: both claimed pregnancy.

During this era, women had no legal rights. All the same, it was against the law for the state to execute a pregnant woman, and no court had the power to condemn an unborn child, no matter how guilty the mother. When

Anne and Mary announced that they were with child and pleaded their "bellies" to the court, an examination was ordered; it confirmed that both women were pregnant.

Neither Mary nor Anne were hanged. Mary Read died of "white fever" on January 24, 1721, after giving birth in prison. Ironically, her husband, also a member also of Calico Jack's crew, was pardoned to raise the child. When Anne Bonny's child was born, Anne used her charms to gain two more reprieves of her death sentence. Although it is not certain what happened to Anne and the baby, many suspect that her influential father paid for her freedom. She is alleged to have returned to South Carolina and later married yet another pirate, Robert Fenwick, who lived at Fenwick's Castle near Charles Town.

The Legend of Gasparilla

A legend is a story handed down for generations, one popularly believed to have a historical basis even though it is not verifiable. The story of José Gaspar, popularly known as "Gasparilla," is a perfect fit for this definition. Our past is composed not only of factual material but also legends, so it is important that the reader knows both to gain an understanding of the beliefs of those who preceded us.

With this understanding, we will share a short mythical version of the most famous pirate of southwest Florida and the subject of many storytellers. After that, we will provide any possible factual basis for the existence or nonexistence of José Gaspar or Gasparilla, so that you can decide for yourself whether he really lived or was merely another of the many legends that make up the history of piracy in the Sunshine State. Or, you can embellish the myth, just as people have been doing throughout its history.

There are multiple and conflicting accounts of the life of Gasparilla. Many of the accounts follow the same basic time frame and generally contain the same events, especially pertaining to his early life.

José Gaspar was supposedly born in 1756 to Ramon and Dulcie Gaspar in the port city of Seville, Spain. As a youngster, though small in stature, José proved to be of supreme intelligence and was skilled in the use of weapons; he often exhibited leadership among his classmates. At the age of twelve, José's involvement with a young girl forced him to leave his home and attend the Royal Spanish Naval Academy in Cadiz. José Gaspar loved women

and, even while at the academy, had affairs with many ladies, including the commandant's niece.

After graduation, José embarked on a naval career in the Spanish navy. On his first mission, against the Muslim Barbary pirates, young José freed both the crew and a ship being held for ransom in Tripoli. He was quickly promoted to captain's rank and joined the Atlantic fleet, successfully battling and capturing many Caribbean pirates. His exploits earned him the title of admiral of the Atlantic fleet in 1782. In the capital city of Madrid, José was lionized by his people and became a hero to the Spanish citizens. Because of his great popularity, José was called back to Madrid to become the naval attaché in the court of King Charles III.

Admiral Gaspar, a cultured and gallant hero, continued to follow his pattern of seducing women, including the king's daughter-in-law, Maria Luisa, who fell madly in love with him. However, at nearly the same time, José met the true love of his life, Dona Rosalita, a beautiful lady of the court. Their marriage, planned as a gala event, evolved into a national event. José and Rosalita then lived in wedded bliss in a palace outside the capital city, and they soon became the proud parents of a son and a daughter.

José was fearlessly honest and outspoken in his criticism of the corrupt bureaucracy that permeated the Spanish government of the time. This made him the political archenemy of the prime minister, Manuel Godoy.

Godoy and the jilted Maria Luisa conspired together to destroy Gaspar's career. While José was in command of a convoy transporting the crown jewels, they sent a band of men disguised as robbers to steal the valuables. Though José fought valiantly to escape the trap, the jewels were taken, and he was falsely accused by Maria Luisa and Godoy of stealing them himself. José managed to return to his home, but upon his arrival, he was forced to witness Godoy's drunken men terrorizing his family. They viciously murdered his young daughter and his mother-in-law and raped and murdered his beloved Dona Rosalita. Waiting until nightfall, José took advantage of the drunken state of Godoy's men and killed all those responsible for his wife's death. He then left Madrid with his baby son, whom he left with a trusted friend.

Before leaving his homeland in 1783 as a wanted criminal, José freed men from the king's jail and took possession of a new Spanish warship, the *Florida Blanca*, which he renamed the *Dona Rosalita*. For the next thirty-eight years José, now using his alias Gasparilla, vented his fury against Spain and become a pirate scourge of the high seas.

As time passed, Gasparilla needed to protect his pirate enterprise and abandoned the traditional ports of call in the Caribbean. He instead

A pirate warning dagger on Cayou Pelau 2011. *Photo by Chris Wicburg.*

established his stronghold on Gasparilla Island, which is located in Charlotte Harbor in the Gulf of Mexico. José lived as a gentleman in a luxurious home near the present-day town of Boca Grande, while his pirate crew resided on the nearby island of Cayo Pelau. Some believe that the carved symbols resembling daggers that can be seen on Gumbo Limbo trees on the island were intended to warn off trespassers.

Writers have recorded or devised various versions of Gasprilla's later pirate life, based on their own perception and interpretations, as is the case with most good storytelling.

José was considered a freedom-loving gentleman, but some maintain that he was also a brutal, vengeful killer who murdered the captured men but held the women hostage for profit. It is commonly believed that Captiva Island was the location where the female captives were held until ransom was paid.

There is a also a recurring story of Gasparilla's capture of a beautiful Spanish princess and his love for her. In spite of his persistent efforts to win her heart, she continued to reject him. At last, in a violent fit of anger,

Gasparilla drew his sword and cut off the lady's head, which flew into the Gulf of Mexico. Then, sorrowful and penitent, he buried her headless body on Useppa Island. There are those who claim to have seen the headless ghost of this princess in the Charlotte Harbor area.

The final chapter in the José Gaspar tale allegedly happened in November 1821. José and his men were planning to leave Gasparilla Island and move their enterprise to South America because the United States government had purchased Florida and was committed to removing all pirates from the coast. A U.S. Navy anti-pirate fleet was now operating from its base in Key West.

As José's pirates were preparing to leave Florida, a slow-moving British merchant vessel was spotted offshore. José and his men could not resist the temptation of capturing one last prize and set sail for a final adventure.

The "merchant" vessel was actually a United States Navy frigate, often referred to as the USS *Enterprise* in the legend. A fierce battle ensued, but outmanned and outgunned, the *Dona Rosalita* was critically damaged and began to sink. Gasparilla, determined not to be captured, leaped to the bow of his stricken ship and shouted to the Americans, "Gasparilla dies by his own hand and not the enemy's." According to the popular version of the story, he wrapped himself in an anchor chain and dived into the Gulf of Mexico. Please note that an anchor chain would have been extremely heavy, and in reality, he would have been unable to lift it.

This enduring tale of southwest Florida's pirate king has been retold and rewritten many times in the last 150 years to become the legend of José Gaspar, Gasparilla.

Next, we will show a perceived historical basis for the larger-than-life character so that you can decide for yourself if it is legend or fact.

ᏟᏂᎬ ᏟᎡᏌᎬ ᖴᎪᏟᎢᏚ ᎪᏴᎾᏌᎢ GᎪᏚᏢᎪᎡᏐᏞᏞᎪ

When we discussed the legendary pirate José Gaspar, or Gasparilla, we maintained that the story is a myth, as there are no historical facts that would indicate that he ever existed, particularly as described in the local lore and legends. However, it appears that pirates used this name during various sackings along the Mexican and Cuban coasts. There is allegedly even a monument in the city of Campeche, Mexico, that honors the citizens who battled and defended their city from an annual sacking by the pirate José Gaspar, who came from an island off the west coast of Florida.

But the historical facts indicate that José Gaspar, Gasparilla, southwest Florida's local legend, simply never existed.

Although the area of Charlotte Harbor and its many nearby islands figure prominently in the legend of Gasparilla, most of these islands along the coast of southwest Florida were named and on navigational maps before Gasparilla and his pirates allegedly arrived. Mound Key is one of many man-made islands built more than two thousand yeas ago for safety against the natural elements and security from possible invaders by the Calusa (also spelled Caloosa) Indians. The island named Sanibel first appeared on a map dating from 1765, listed as Puerto de S. Nivel (loosely translated to San Nibel), long before the tale of Gasparilla. Fishing ranchos, populated by Cuban Spanish fisherman, dotted the coastal islands from the 1600s until 1900. The islands were known then by the same names we know today. They include Gasparilla, Cayo Costa, Pine Island, Sanibel, Estero and Captiva Islands. Gasparilla Island probably received its name from a Spanish Catholic missionary, named either Gaspar or Gasparilla,

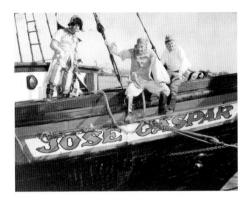

Modern-day pirates at Gasparilla Days, Tampa. *Florida Archives.*

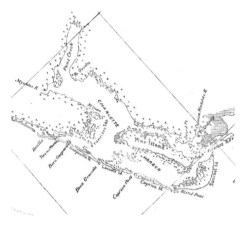

A 1774 map, showing early Gasparilla Sound. *Florida Archives.*

who established a mission there to minister to the Spanish fishermen and Calusas who traded with them. This transpired before our legendary character supposedly lived there.

The Spanish were known for their meticulous recordkeeping. There is no record of José Gaspar's service in the Spanish navy during the period he was alleged to have quickly risen to the rank of admiral. In fact, nowhere in either Spanish or American history is there any information that would indicate that the mythical José Gaspar ever existed.

During the alleged years of Gasparilla's reign in southwest Florida, 1783–1821, there was little pirate activity reported on Florida's west coast. During the period between the American Revolution and the War of 1812, there was minimal maritime traffic among the harbors in the Gulf of Mexico. Most piracy during this period occurred off the northern coast of Cuba, through the Florida Straits and along the Florida Keys and the eastern coast of Florida.

The person who gets most of the acknowledgement for telling and retelling the basic Gasparilla pirate story was John Gomez, also called Juan Gomez. Gomez was a colorful character and was himself a living legend in southwest Florida. He claimed to have been born on the Portuguese island of Madeira in 1778. At the age of twelve, when his family moved to Lisbon, he ran away from home. When he was fifteen, he became a cabin boy on a French ship of the line but deserted it for a Spanish merchant vessel named the *Villa Rica.*

During his tenure as a sailor on the *Villa Rica*, Gomez traveled extensively. He maintained that his ship was blown off course in 1801 by a late September hurricane and was captured, looted and burned near the southwest Florida coast by the pirate Gasparilla, who killed all aboard except Gomez and eleven Mexican girls. Gomez then described how Gasparilla assigned the girls to members of his crew, except for one who was alleged to have been the daughter of a Mexican viceroy. Gomez said that Gasparilla fell in love with this girl, Joséfa, but later beheaded her in a fit of rage. These events were a prelude to Gomez's experiences with Gasparilla, the pirate king of Boca Grande.

Juan Gomez then allegedly went to Spain, under orders from Gasparilla, to assassinate Manual Godoy, the prime minister of Spain. He never reached Godoy but instead joined the French army's Black Dragoons. He also claimed that Napoleon Bonaparte also spoke to him. According to Gomez, Napoleon patted him on the shoulder and said, "You will make a fine soldier someday." The complex Gomez said that he then deserted his post and joined a ship bound for Charleston, South Carolina.

Gomez spent the next ten years as a crew member on a slave ship. He didn't talk much about this part of his life. However, Gomez stated that in 1818 he was again captured by the pirate Gasparilla and spent the next three years on Boca Grande as a member of the pirate confederation. Gomez claimed to have witnessed from shore the demise of Gasparilla at the hands of the American navy pirate hunters. He and the other pirates left on shore took a small boat, sailed down Pine Island Sound and took refuge on Panther Key, located in the Ten Thousand Island area of the Florida Everglades.

Gomez eventually boarded a schooner sailing to Havana, Cuba, and resumed his career as a crewman on a slave ship. It should be noted that slavery was a lucrative business, and those who participated in this trade were often well rewarded financially, compared to merchant seaman or naval sailors with their lower wages.

In 1831, Gomez was involved in a revolt against Spanish authorities in Cuba and was forced to flee to St. Augustine. The Golden Age of piracy was now over, and few traditional pirates remained, so he stayed in St. Augustine until he was hired as a scout for General Zachary Taylor's command during the Seminole Wars. Gomez was fifty-nine years old when he fought in the Battle of Lake Okeechobee on Christmas Day 1837. The following year, he was discharged from service and moved to Cedar Key on the Gulf Coast to become a "cracker," or a Florida cowboy. He remained there until 1855.

At seventy-seven years of age, Gomez returned to Panther Key and built a palmetto shack. During the Civil War, he returned to the sea and, by his own words, became involved in blockade running, which paid him handsomely. When Gomez was eighty-seven years old, he still possessed great physical prowess. He often challenged younger men to physical competitions such as tree climbing contests, and he regularly climbed coconut palms seeking milk nuts, as he called them.

Gomez became a friend of Walter T. Collier and his son, William D. Collier, who were traders. In 1870, they constituted the first white settler family to live on Marco Island, and they eventually operated a general store. The Colliers were impressed by John Gomez and regaled in the stories the old man told them.

In 1884, 106-year-old John Gomez arrived back on Panther Key with his new bride, a well-educated 78-year-old lady who had married him in Tampa. The couple soon fell on hard times and became destitute.

Friends of Gomez, led by Captain Collier, traveled to Fort Myers and requested that the commissioners of the newly formed Lee County pay Collier's store the sum of eight dollars per month to provide food and clothing to the destitute couple living on Panther Key. These payments may have constituted the first welfare payments made by Lee County.

When news of the old ex-pirate living on southwest Florida's Panther Key spread, it brought many a sailor, yachtsman and treasure hunter to the area. They yearned to meet Gomez and listen to his many yarns of pirates, years in the slave trade or military adventures. John Gomez made a considerable amount of money by dispensing his incredible stories to those willing to listen to them and by telling where treasures were allegedly buried. The stories were believable since he always cast himself as a minor player or someone who knew something others did not.

One hot July day in 1900, Gomez, now a legendary old man of 122 years, went fishing in his beloved Gulf of Mexico. It was to be the old pirate's last voyage. Gomez apparently became entangled in the draw cord of his casting net and was thrown overboard. He drowned in the clear blue water.

Coincidently, 1900 was also the year when the first written version of the Gasparilla legend appeared in an advertising brochure of the Charlotte Harbor and Northern Railroad Company operated by Henry B. Plant. This brochure, given to customers of the railroad and the Boca Grande Hotel, relied heavily on the stories told by John Gomez.

In 1902, after Plant's death, the Plant Railroad Empire was sold. The offices were moved from Charlotte Harbor to Tampa, along with the

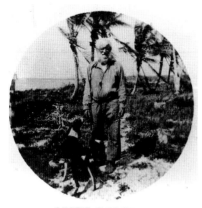

JOHN GOMEZ,

Generally known as Panther Key John, a brother-in-law of the Pirate Chief Gasparilla and a member of his crew, who died at the age of one hundred and twenty years, at Panther Key, Florida, 12 miles below Marco, in the year 1900.

The above photograph was taken with one of the old-style "Pull-the-String Press-the-Button" Kodaks during the winter of 1895, when he was one hundred and sixteen years old, by one of our winter tourists, who kindly loaned us the negative.

WICKMAN'S PHOTO SHOP
Boca Grande. Florida

Photo of Juan Gomez, pirate tale teller. *Florida Archives.*

Gasparilla legend. The businesspeople of Tampa, originally wanting to promote a Mardi Gras–type of event for the city, were inspired to promote the first Gasparilla Pirate Days celebration in 1904. Today, it has become one of the most popular festivals in the world. Another irony is that southwest Florida's Pine Island, near Gasparilla Island, was named "Tampa" on early navigational maps.

The book *Our Navy and the West Indian Pirates*, published in 1929, makes no mention of Gasparilla's pirate kingdom in Charlotte Harbor. It does, however, mention an incident in which pirates robbed the ship *Orleans* of more than $40,000 in dry goods when it was sailing off the Abacos Islands in the Bahamas in September 1821. The leader of the pirates gave a note to the U.S. naval officer, who happened to be a passenger on board. The note stated, "Between buccaneers no ceremony. I take your dry goods and in return I send you pimento; therefore we are now even. I entertain no resentment; the goods of this world belong to the brave and valiant." It was signed, "Richard Coeur de Lion." Somehow, Richard Coeur de Lion and the mythical José Gaspar became one and the same, at least in the Gasparilla legend.

Various early twentieth-century historians were taken in by the business interests promoting the Gasparilla festival in Tampa and reported the existence of José Gaspar or Gasparilla as historical fact. Apparently, the legend had been reproduced so many times that it was represented to be fact by succeeding historians in the early 1900s.

It is important to note that many of the pirates described in the pirate lore of southwest Florida are often tied to the mythical Gasparilla of Charlotte Harbor.

Lafitte's Gold and Other Legendary Treasures

We mentioned that Mound Key and other mounds belonging to the Calusa Indians were man-made and briefly illustrated the engineering genius that marked them as among the first land developers in what was to become the Sunshine State. And if that is true, then Jean Lafitte could certainly be considered a foremost pioneer in regional mall development. Witness to this idea were the massive shopping centers he established on Grand Terre Island, also known as Barataria Island, in Barataria Bay south of New Orleans.

In almost every area claiming to have had pirates, there are also stories of pirate treasures of gold and silver or hidden chests of pirate booty. One of the most famous of these legends, which stretches along the west coast of Florida and much of the lower Keys, is that of Jean Lafitte's hidden treasure. Unlike most people who attempt to hide their wealth, Jean Lafitte contributed to these tales, often boasting that he personally supervised the concealment of millions of dollars of gold and other valuables. He once stated that, along the coast of the Gulf of Mexico, he had buried enough gold to build a solid-gold bridge across the Mississippi River. Lafitte employed thousands of sailors and used many ships to raid and plunder shipping throughout the Caribbean. Many of these sailors and ships made port in the deep waters of Charlotte Harbor and Tampa Bay in Florida, which makes some of the exaggerated claims of Lafitte's treasure on the Mangrove Coast a possibility.

Jean Lafitte, born in France, was handsome and was conversant in French, Spanish, Italian and English. He was a polished gentleman and a

shrewd businessman who amassed a fortune by smuggling slaves and merchandise past the local customs inspectors. Lafitte and his brother, Pierre, operated his enterprise from his roost on Grand Terre Island. Jean established a commune in 1807 that included a café, a bordello, a gambling den, warehouses, a barracoon (for detaining slaves) and outdoor bazaars that offered silks, spices, wines and furniture. Grand Terre Island, with its deep-water harbor and location at the entrance to the Mississippi Delta, made an ideal fortified outpost area to control the entire import traffic of the

Pirate king Jean Lafitte. *PD-US.*

lower Mississippi River. Lafitte also had his hand in most of the shipping throughout the Gulf of Mexico, including southwest Florida, during the period of his pirating adventures.

Lafitte's treasure was alleged to have been buried in every inlet and on every island along the entire coast of the Gulf of Mexico. The Lafitte brothers were rumored to have buried millions of dollars worth of treasure in both San Carlos Bay and along the Peace River in Charlotte Harbor. However, Jean Lafitte, historically called "the Pirate of the Gulf," was an entrepreneur and seldom went to sea himself. He instead hired and outfitted hundreds of privateers, actually pirates, to go forth and bring wealth back to him. A contemporary of Lafitte and a fellow Frenchman, Louis Aury, also began his pirate career by raiding small communities and merchant ships off Florida's west coast.

Aury impressed Jean Lafitte with his fearless attitude and excellent

Lewis Aury, an early Florida pirate. *Florida Archives.*

fighting skills, and he was ultimately responsible for many daring predations on merchant vessels not only throughout the Caribbean but also along the Atlantic coast. He ultimately became associated with the Lafitte brothers on Galveston Island.

Jean Lafitte seems to have taken credit for most of the pirate activity that took place throughout the Gulf of Mexico during the years that he lived there. In reality, he turned the historic established form of piracy into a vast business conglomerate that concentrated on smuggling and illegal business dealings. He is one of history's most enigmatic characters, and Lord Byron is quoted as saying, "He left a corsair's name to other times, Linked one virtue to a thousand crimes."

Lafitte was both cruel and generous, a patriot and a pirate. The accounts of his life document his many dealings and compromises. His reputation was so notorious that one French legend even describes Jean's bargain with the devil. According to this tale, his castle, named Maison Rouge (Red House) and located on Galveston Island after the War of 1812, was built for him by the devil in a single night. In exchange, Lafitte offered to the devil the life and soul of the first creature that Lafitte would cast his eyes on the next morning. Lafitte then arranged to have a dog thrown into his tent at daybreak, so that all that the Devil got out of the deal was a dog.

There are few characters in American history as complex as Jean Lafitte. Andrew Jackson, an American hero in the War of 1812 and later a United States president, actually condemned, exonerated and again condemned Lafitte. When he sought Jean Lafitte's help in fighting the British, Lafitte, always the negotiator, agreed to fight for the Americans if Jackson would extend clemency and grant citizenship to his privateers, the Baratarians. Jackson consented, and most historians agree that without Lafitte's powder, flints and massive artillery barrage courtesy of Dominique You, Lafitte's half-brother and a fellow privateer, Great Britain would have won the Battle of New Orleans that foggy morning of January 8, 1815. Following the conflict, General Jackson requested clemency for the Lafitte brothers, and they were pardoned on February 6, but they lost their pirate privileges. Lafitte then moved to the Spanish-occupied territory of Texas with his crew and took over Galveston Island. There he resumed his pirate activities and built Maison Rouge. He was embittered that America had rejected him as a privateer, and he died a broken man on May 11, 1821.

Jean Lafitte will be remembered for two reasons. The first is that he was a proud and gallant American hero for a few glorious hours on the field at Chalmette near New Orleans in the War of 1812. The second reason, not

so noble in our archaeological history, is that he has become known as the man who claimed to have buried gold and other treasures in every inlet and on every island along the entire Gulf Coast.

A serious outcome from pirate tales of buried treasure is an environmental concern. Based on these stories of gold and gems, many of our beaches, islands, rivers and inlets have been dug up, with no pirate

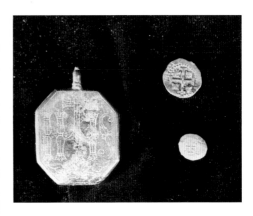

Spanish treasure coins. *Florida Archives.*

booty found. Although coins, pieces of silver and other items have been discovered on occasion, these do not equal a valuable treasure-trove. There is even some evidence that items may have been "planted" by those residents who might profit from visitors coming to search for hidden treasure. Tragically, people who normally act in a rational manner have destroyed Indian mounds, graves and historical sites while looking for Lafitte's and others' secret caches. Most historians agree that there are few treasures to be found buried since the pirates' lifestyles and short life expectancy made securing their stash a low priority.

Other alleged treasures buried on the Mangrove Coast of southwest Florida are, again, usually related to legendary pirates who were contemporaries of the mythical José Gaspar. Most notable of those is Brewster Baker, who reputedly lived on Pine Island and is claimed to have buried gold and silver coins on the island.

Brewster Baker may have been one of the most successful of the little-known pirates who operated in the waters around Florida. His name has been used as the fictional name of an outlaw in the Wild West and was also used in several cowboy movies of the 1940s and 1950s. In addition, "Brewster Baker" is the main character in the 1982 comedy/drama movie *Six Pack*, a film that featured NASCAR stock car racing in its early years. Many references to this name or character are indeed known—and not only as a Florida pirate.

Baker is said to have been a British naval officer in the late 1700s. In 1797, while serving as a lieutenant aboard the British frigate HMS *Heather* near the coast of Barbados in the Caribbean, he successfully led a mutiny against the

captain. Baker and the seamen loyal to him stranded the remaining crew on shore and were thus logically forced to become pirates. The first ship that they captured, off the French island of Guadeloupe, was the *Andre Follet*, a French ship of adequate size and speed to become their flagship. To avoid capture, Baker and his men sailed into the Gulf of Mexico and sought refuge on one of the many islands dotting the Mangrove Coast.

British navy regulations of the late 1700s required that any naval ship operating in the waters around Florida could not cross over the mean high tide line when in pursuit of a combatant or pirate. This was primarily a safety issue as the waters in the Gulf of Mexico are often very shallow. Ships that ran aground were liable to sink or suffer attack from their original target.

As a former British officer, Brewster Baker was well aware of this British rule, and he used it to his advantage. Baker often entered San Carlos Bay or the mouth of the Caloosahatchee River, knowing that the British would abandon the chase once his ship was safely on the land side of the mean high tide line.

The barrier islands along the southwest Florida coast allowed Brew Baker, as he began calling himself, many avenues of escape from naval authorities. One of Baker's favorite ploys was to sail his ship up Long Cut at the south end of Pine Island. He would then attach rigging to his tall masts, and after going ashore, some of the crew would pull the ship over and tie the top of the masts to the dense mangrove trees. From the water, the masts could not be seen and the dense mangroves provided camouflage so that pursuers could not find his ship. Long Cut became known as "Bru Baker's Cut" among the fishermen around Pine Island and was also noted as such on many maps.

In 1798, Brew Baker and his men sailed up Pine Island Sound and established a pirate community on the small island of Bojelia just off the northern tip of Pine Island. The English sailors soon were pronouncing this name "Bokeelia." Because of the shallow waters surrounding Bokeelia, large vessels could not approach it, which gave Baker a vital defensive advantage with his limited crew of men. The island had a fresh water supply and fertile soil. Fish were plentiful in the area, and the sandy beaches provided an excellent area to careen ships. Baker and his men set up a village of palmetto-thatched huts and established trading links with both the Indians and the Spanish fishing ranchos in the area. From this community, Baker and his pirate crew sailed to plunder the north coast of Cuba, as well as the shipping lanes from Latin America through the Florida Keys.

Baker, who in later years was also known as Bru Baker and Brubaker, allegedly worked with the legendary José Gaspar in Charlotte Harbor, as well as with the Lafitte brothers, who were based near New Orleans at the time. The presumed association with the Lafitte brothers could possibly have some historical merit, although we question the existence of José Gaspar.

By 1820, Florida had become a United States territory, and there was concern about the attacking and plundering of American ships off the coast of Florida by outlaws. Insurance companies and politicians demanded that effective action be taken against these audacious Florida pirates, so in 1821, President James Monroe authorized the United States Navy to establish an anti-pirate squadron in order to rid the Caribbean of piracy. David Porter was appointed to command this unit, which included the first steamship used by the U.S. Navy.

With the American navy threatening his settlement on Bokeelia, Brew Baker and his crew reportedly sailed from Charlotte Harbor intent on resettling in South America. En route, Captain Baker went ashore in the Gulf of Darien and was attacked by native Indians. He suffered a poisoned arrow to the chest and died an agonizing death.

In addition to the many treasures claimed by Lafitte, some other legendary treasures allegedly buried on the west coast of Florida include the following sites and information.

Calico Jack Rackham allegedly buried more than $3 million somewhere in the Ten Thousand Islands.

Fourteen tons of silver plundered by Black Caesar the second is claimed by some to be underground on the coast of Sanibel Island.

The mythical pirate José Gaspar, Gasparilla, supposedly secreted more than $2 million worth of gold and silver on Gasparilla Island.

Indian gold and silver worth millions, stolen from the Spanish or recovered from shipwrecks, is allegedly buried inland from Mound Key north to Tampa Bay.

Legends of sunken treasure ships around Florida still persist to this day in spite of modern sophisticated electronics, frequent military maneuvers and activities of both the air force and navy, the existence of companies that hunt buried and sunken treasures and the fact that Florida waters are among the most dived waters in the world. As discussed previously, if the treasures actually existed, they would probably have been discovered by now. With that in mind, it's easy to presume that each of the following is more legend than actual fact.

April 4, 1528—Panfilo de Narvaez landed at a place he called Santa Cruz, today believed to be Sarasota Bay. He left four ships, one of which was destroyed and sank with unknown treasure. Narvaez was never found.

1529—A Spanish ship wrecked at Punta Rassa. The ship was a Hernando de Soto supply ship that was caught in a storm and sank at the mouth of the Caloosahatchee River. The cargo was alleged to have been the payroll, armament and supplies for De Soto's expedition.

1535—A Spanish fleet under the command of Hernando de Soto went aground on the coast near present-day Tampa Bay. De Soto had named the area "Espirito Santa Bay," or Bay of Holy Spirit.

1563—Two Spanish ships, part of a fleet under Pedro Menendez de Aviles, disappeared near present-day Charlotte Harbor.

1600—An unnamed, two-hundred-ton nao (three- or four-masted ship), built in France and coming from Mexico under the command of Captain Diego Rodriquez, sank off the west coast of Florida near the Ten Thousand Islands.

1622—The Spanish Plate fleet lost eight ships during a hurricane near Loggerhead Key in the Dry Tortugas, including the *Nuestra Senora de Atocha* and the *Santa Margarita*, which indeed did carry treasure and have since been salvaged.

1641—A Spanish galleon, *San Cristoforo*, was caught in a hurricane and sank in shallow water off the north end of Sanibel Island. The cargo was reported to contain over $1 million in gold bars and coins.

1733—A Spanish galleon wrecked at Clam Pass. The vessel was part of a Spanish fleet sailing from Mexico to Cuba. A hurricane scattered the remains along the shoreline of Clam Pass, where gold coins were found on the beach.
 A Spanish galleon, sister ship to the ruins found at Clam Pass, was sunk by a hurricane. It had a cargo of more than $1 million in gold coins that was never recovered.
 A Spanish galleon, either part of a fleet caught in a hurricane or sunk later by pirates, went down at the mouth of Caxambas Pass south of Marco Island. The treasure cargo is unknown.

1803—A British warship sent a pirate boat to the bottom about half a mile offshore from Black Island. The pirates were captured and hanged. The cargo was never recovered.

1817—An unidentified wreck was discovered at Bocilla Pass. It was believed to have been sunk by pirates in the area. Cannons and ballast were recovered from this site. The cargo was unknown.
 A pirate ship was sunk by British ships off La Costa Island. It was believed to be part of Jean Lafitte's fleet of privateers. The crew was captured and hanged under British admiralty law.

1821—The ship *Florida Blanca*, allegedly Gasparilla the pirate's flagship and treasure vessel, was sunk by the American navy with a treasure on board of $9 million. This obviously never occurred.
 An American frigate and its treasure lie at the gulf entrance to Big Gasparilla Pass. The ship was carrying more than $1 million in coins bound for New Orleans.

1863—A Confederate ship, the *Queen Mary*, was sunk by the Union navy warship *Hatteras* offshore from Captiva Island at Redfish Pass. The *Queen Mary* was carrying guns, ammunition and payroll money to Tampa for overland shipment to the Confederate army.

Since the Civil War, there have been many more ships and barges sunk in the waters off the coast of southwest Florida. Many of these were yachts and ships belonging to some of the richest men on earth and are rumored to have carried valuables.

There is an interesting story of Battista's Gold. Allegedly, a B-25 plane that belonged to Cuba's deposed dictator was carrying $25 million in gold and fleeing the country over the southwest Florida coast. It is believed to have crashed into the Gulf of Mexico during the Cuban revolution that saw Fidel Castro seize power.

However, if you would like to organize a treasure hunt, it might be wise to simply invest in a metal detector and settle for some of the modern coins and jewelry that you might find on our busy tourist beaches.

If you want to seek historical finds in southwest Florida instead, invest in a spaghetti colander and diving mask to look for megalodon shark teeth. From Boca Grande north to Venice Beach and the inland waters, these seven- to ten-million-year-old sharks' teeth turn up on a regular basis. There is

no doubt that these teeth have a true history, unlike some of the treasures described in this chapter.

Some studies indicate that there is more gold underwater in the world's oceans than is available on land today. Unfortunately, Florida, southwest Florida, the Keys and our part of the Gulf of Mexico are probably not the repositories of this gold, or of any other buried or sunken treasures. You are urged to enjoy the legends of buried treasures, but always respect our environment.

Keys Wreckers

On April 2, 1513, when Ponce de Leon claimed La Florida in the name of Spain, the Spanish government never considered the rights of the Florida Indians. Florida was "owned" and governed by Spain from 1513 until it was ceded to England in 1763. Twenty years later, the British gave Florida back to Spain to keep it from becoming part of the United States. Yet another land transfer occurred in 1819 when Spain sold Florida to the United States. After ratification of the treaty, Florida, as well as the necklace of islands called the Florida Keys, officially became American territory.

The Florida Keys were shown first on nautical charts in the early 1600s, and from that time until the early 1800s, no country ever controlled or successfully governed them. When Cayo Hueso, or Bone Island, later named Key West, was first explored by the Spanish, it was covered with the bones of dead natives. As the European colonists on the eastern coastline of North America pushed southward, the indigenous Indians were driven out and finally pushed into the upper Keys. At the same time, the mighty Calusa Indians of southwestern Florida were also forced to Cayo Hueso and the lower Keys. Eventually, the stronger tribes from the north faced the Calusa in the lower Keys. Though many of the Calusas left for Cuba or other Caribbean islands, the remaining warriors were forced to fight the northern tribes with their backs to the water. After the massacre ended, the bodies were left to decompose on the island, leaving Cayo Hueso literally covered in bones.

While under the control of Spain and England, ownership of the Keys did not matter in Cuba, where the Spanish authorities continued to issue permits to Cubans allowing them to fish in the Keys. Cayo Hueso was even called "Norde de Havana," or "Northern Havana." The Cubans established fishing ranchos in the Keys and the west coast of Florida at which they caught, cleaned and cured fish to be shipped back to Cuba. The Bahamians also came to the Keys and harvested the mahogany and other hardwoods for building their boats. Many stayed to hunt turtles and salvage treasure from the shipwrecks. In addition, Europeans serving on privateers moved ashore and then began living on these keys themselves. This unusual and eclectic population guaranteed a governing challenge for any country.

Meanwhile, successful pirates like Jean and Pierre Lafitte, Black Caesar, Charles Gibbs and countless other European pirates were turning their enterprises into thriving and profitable businesses. Not surprisingly, this led to pirate monopolies, which adversely affected the economics of the United States. With the acquisition of the Florida territory in 1819, the United States was finally in a position to suppress piracy in the Caribbean Sea, the Antilles and the Gulf of Mexico region. President James Monroe felt that this was essential to ensure the future success of his dream for our young country, a guideline for our place in the hemisphere.

The proposed Monroe Doctrine would prohibit European countries from further colonizing in the Western Hemisphere. The document's intent was that the United States would neither interfere with European colonies currently existing nor meddle in the internal concerns of European countries. The doctrine would clearly state that the New World and the Old World would remain separate as they were composed of entirely separate and independent nations.

James Monroe deserves the title of one of America's Founding Fathers. He was a fighter both in politics and in the field of battle. During the American Revolution, Monroe manned the boat that George Washington used to cross the Delaware River on a cold Christmas Eve in 1776. The goal was to surprise the British and capture Trenton from the British, and it was a successful victory. Monroe suffered a near fatal wound in the shoulder while valiantly attacking an artillery battery later during the Revolutionary War and carried the musket ball in his body for the rest of his life. Courageously, President Monroe was willing to declare a war on the pirates of the Caribbean.

Although the United States Navy had been fighting piracy and the slave trade along the coastline of Florida since 1817, the true war on pirates began after a pirate attack in September 1821 in which three American

merchant ships were captured and the crews tortured. Congress authorized navy commodore James Biddle to dispatch a fleet of ships to the area.

By 1822, the West Indies Squadron was in place to battle the buccaneers of the area around Florida. The pirate war lasted until May 1825 and effectively ended the Golden Age of piracy, although isolated battles lasted well into 1830.

The West Indies Squadron was composed of many famous ships during its battle to end piracy. Lieutenant Lawrence Kearny, with the USS *Enterprise*, captured eight pirate ships and 160 pirates in one single day in April 1821. The *Enterprise* was the most famous ship of the pirate war, responsible for taking thirteen pirate and slave ships during the war. One of the pirates captured by the *Enterprise* was Charles Gibbs, among the most brutal pirates of all time, Gibbs admitted to killing 400 victims.

Another famous ship of the squadron, the USS *Alligator*, was a schooner under the command of Lieutenant William Allen. It captured three pirate ships and more than one hundred pirates in November 1822. Lieutenant Allen was shot in the chest and died during the fight. On the way back from the battle, the *Alligator* wrecked on what is now called Alligator Reef on November 19, 1822. The current city of Key West, at that time known as "Thompson's Island," was renamed Allentown in honor of Lieutenant Allen.

The *Alligator*, under the command of Lieutenant Richard Stockton, had earlier captured Jean Lafitte. The Americans claimed that Lafitte had attacked the American ship *Jay*, although this action was questionable, since Lafitte was later credited with escorting the American merchantman *Columbus Rose* through pirate-infested waters to safety.

The *Gallinipper* was one of five unique U.S. Navy boats equipped with sails and double-banked oars and specifically designed for duty in the pirate war. It served honorably and was credited with a number of captures of both pirate ships and pirate crew members. The *Gallinipper* was one of the last American navy ships to use oars for power.

The USS *Sea Gull* was the first steamship used by the American navy during the pirate war. It was the first steamship in U.S. naval history. It served so well that steam eventually replaced sail.

USS *Grampus*, on March 2, 1825, defeated and captured the famed pirate Roberto Cofresí, one of the last successful Caribbean pirates of this period. Cofresí was executed on March 29, 1825.

During the pirate war, the naval fleet had more problems than only contending with piracy. The climate was abysmal, with numerous tropical storms and hurricanes in the region. Commodore Biddle was tired of chasing

the pirates, who often played hide-and-seek with his ships and marines. Yellow fever, common in the area during the summer season, struck down more than one hundred of his men. Frustrated with a guerilla-type war, Biddle resigned his command.

President Monroe sought a replacement for Biddle, a seasoned fighting man who would aggressively take fire and sword to the pirates and end the threat of the pirate enterprise permanently. Monroe chose David Porter, one of the first officers of the fledgling United States Navy, who had been appointed early on by President George Washington. Porter, the commanding officer of the *Essex* during the War of 1812, was noted for scoring America's first victory over a British warship.

David Porter is given credit for defeating a majority of the pirates during the command of what he called his Mosquito fleet. However, after the Monroe Doctrine was introduced on December 2, 1823, he was court-martialed for disobeying orders and attacking a Spanish town outside of American territory in Puerto Rico. Porter claimed that his attack was no different than that of General Andy Jackson, who earlier had led an unauthorized invasion of Spanish Florida. Before he could be sentenced, David Porter resigned his commission and moved to Mexico. Ironically, he returned to the United States after Andrew Jackson became president and was then appointed to be the American minister in Constantinople. He died there of heart disease in 1843.

Before James Monroe left office in 1825, the United States declared a victory in the pirate war, citing that the U.S. Navy had captured more than eighty pirate ships and condemned more than 1,300 pirates. After the American navy claimed to have cleared the southern seas of pirates, it actually enhanced a unique new industry in the Keys and Florida territory called "wrecking."

Wreckers were people who went to sea and saved the crew of a sinking ship or one run aground on the reefs of the islands that make up the Florida Keys. The wreckers then salvaged the cargo of these ships. Sometimes wreckers were heroic and had noble purposes, but more often they were former pirates and their financial motives remained the same. The income derived from wrecking was intended as a reward or payment from the owners of the wrecked ships for the recovered merchandise. Wrecking eventually became a business sanctioned by the government.

The first wreckers or salvagers in the Keys were the indigenous Florida Indians. The Spanish employed them to help recover what they could from their ships that ran aground or sank. The Indians, who were proficient

A cannon recovered from sunken vessels. *Florida Archives.*

swimmers and divers, brought treasures from the wreck in exchange for rewards from the Spanish.

The Bahamians were believed to have been the first to actually turn wrecking into a profitable industry. Following their system, a claim could be filed by the wreckers in either Nassau or Havana. The claim could then be settled directly between the owner of the shipwreck and the salvagers. The Common Laws at Sea and the Bahamian Admiralty Court set the legal standards for wrecking.

One reason for the frequent shipwrecks in the Florida Keys was the construction of the merchant ships during that era. The early ships were square-rigged ships, often overloaded due to avaricious ship owners constantly looking for substantial profit. These ships were difficult to sail and awkward to maneuver, particularly going into the wind. The phrase "learning the ropes" came from the massive number of various ropes and lines that were required on a sailing ship.

Another problem was the lack of charts or maps, as well as little in the way of channel markers, lighthouses and navigational markers. Fierce weather also could not be predicted.

Added to this, the waters off Cayo Hueso even today are considered treacherous in the best of circumstances and could be deadly given any deviation from the best sailing conditions. The upper Keys were even more dangerous waters for the massive overloaded ships. Many of the noted Keys wreckers lay in wait at either Carysfort Reef or near Tavernier, ready for quick action when a wreck took place.

Learning the ropes on a sailing ship. *Florida Archives.*

The territory of Florida set its own wrecking acts in 1823 in response to the numerous legal problems of the navy's West Indies Anti-Piracy Squadron. The squadron had attempted to halt piracy without written legal statutes. So, the Florida Wrecking Act stated that all wrecked property must be reported to the nearest justice of the peace or notary public. A jury of five people would then be formed. The wrecking jury would consist of two persons nominated by the salvers, two named by the ship owners and one appointed by the justice or notary. There were also court costs, advertisements and a certified copy of the claim that was sent to the Superior Court. Wrecking in Florida, therefore, became a legal business, sanctioned by the courts.

Also written into the wrecking act were terms that charged a person guilty of felony for "the holding of false lights, signal devices, or anything with intent to mislead, bewilder, or decoy the mariner of any vessel on the high seas." This was necessary wording, as early wreckers often would start fires or lights to guide a ship into rather than away from a dangerous reef. They also would move lights about or snuff them out to deceive the ships, which then ran onto the shallow reefs. In addition, wreckers were known to give bad advice concerning the routes of mariners.

One item omitted in the Florida Wrecking Act was the disposition of a salvaged ship. Wreckers found it in their best business interest to burn a wreck after removing everything of value, but as a consequence, there would then be nothing left above the waterline to warn future mariners that dangerous wreckage lay underneath.

For lifestyle, wrecking was different from the piracy that transpired on the water. Seagoing pirates voyaged for long periods of time and could engage in little else. A pirate typically led a hazardous, uncomfortable life and, for many reasons, found it difficult to survive. Wreckers, conversely, could enjoy a decent family life.

Even as most wreckers lived and raised their families near the most dangerous reefs, they usually had other jobs in addition to their salvage work. And often these individuals turned to other occupations when they retired from wrecking.

As one example in the upper Keys, Captain Ben Baker turned to pineapple farming on both Key Largo and Plantation Key. Seafarers turned growers like Captain Baker had been fascinated with pineapples since Christopher Columbus was welcomed by the Carib Indians, who offered him juicy slices of the fruit as a sign of friendship and hospitality. The pineapple, therefore, became known as a symbol of welcome. Florida sea captains might place a

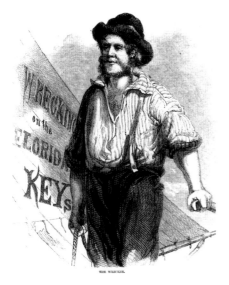

A portrait of a Keys wrecker. *Florida Archives.*

pineapple at the front door of their house to let everyone know that they had returned from a sea voyage and that the home was open to visitors.

Many wreckers also could easily catch turtles or harvest their eggs as a means of income, as the Keys are rich with a variety of them. Turtle hunters used a three-pronged spear that had a line attached when at sea. They sold not only the meat but also the shells, especially those of the hawksbill turtle, which were in great demand for jewelry and comb manufacturing.

During the summer months, the turtle eggs were harvested. The hunter would lie quietly in the beach sand, looking out through the sparkling ripples of the shoal water and listening intently. Often he would spot a break in the water, accompanied by hoarse breathing as a huge form arose from the edge of the sea; he had to lie perfectly still until the large turtle came ashore to nest and lay her eggs. After the hundreds of eggs were laid, the egg hunters would approach the helpless turtle, turning it over so that they might steal the eggs. This hunting was referred to as "turtle-turning" and is illegal in present times.

In the 1800s, sponging was also a big industry in the Keys and another source of potential income for the wreckers. Although a large percentage of the sponges were too coarse for harvesting and sale, those that were suitable provided a good source of income. The sponger became adept at sliding his shallow craft over the sponges to select the most saleable sponges. The capture of these jelly-like creatures required skill and experience as they were loaded with water and very heavy. In some places, the spongers dived for their prey; in the shoal water, they grappled the sponges.

After harvesting, the sponges were loaded onto small schooners and taken to Cayo Hueso and a place on the island called Conchtown. There they were deposited to be dried. Almost every yard in Key West had sponges hanging on the fences. Those in the sponging industry became known as "conchs," a term that was originally applied to the early Bahamian immigrants.

Keys wreckers at work salvaging a wreck. *Florida Archives.*

Other wreckers made their alternate living by fishing or bird hunting. Many birds, in particular the snowy egret, were sold for their brilliant plumage. The exquisite feathers were bought by milliners and women's gown designers.

The common factor of these secondary wrecker vocations was that they were practiced near or on the water, thus allowing the wreckers to be in a position to watch for shipwrecks. Wrecking carried the possibility of bringing them great wealth at any moment, and therefore, they considered it their key to the future.

In nearly every instance, when a wrecker filed a claim, he was rewarded financially. One exception occurred when the men salvaged a ship with a cargo of beer. Since so much beer was consumed by the salvagers, the court ruled that no additional payment was due the wreckers. It was noted that they "had drunk their pay."

It was vital to be the first at a shipwreck. That person became the "wrecking master" and got to choose the assisting salvagers. Many individuals became quite wealthy from wrecking, and during the 1830s, Key West was considered to be the richest city, per capita, in the United States. Among the most notable wreckers who worked the Florida Keys were John Lowe, Jacob Housman, Captain Ben Baker, John Gieger, "Bull" Waterford and "Hog" Johnson.

Beginning in 1820, in order to provide for safer navigation and to prevent ships from destruction along the Straits of Florida, a series of lighthouses was constructed. The first ones were placed at Cape Florida, Sand Key and the Dry

Sand Key Light off Key West. *Florida Archives.*

Tortugas. They were forty-five feet high, though some seemed shorter due to the water depth. More lighthouses were erected through the 1880s, and eventually the chain of lighthouses extended from Cape Florida all the way southwest to the Dry Tortugas.

Most of these lighthouses were masonry, but some were iron "day beacons" that were placed offshore along the reefs. These were built on a screw-pile design that was anchored into the ground, and each had an alphabet letter to identify them. Ships then became very aware of the dangerous Florida reefs.

As more ships were powered by steam, the number of shipwrecks began to decline. Steamships were now able to steer in any direction no matter the direction of the wind and were far less susceptible to the whims of nature.

In 1921, about one hundred years after it was founded, the Wrecking License Bureau of the Court was closed. This date marks the end of the romantic era of the pirate wreckers in the Florida Keys.

The Development of Florida and Civil War Blockade Runners

There has long been a saying that if you want to experience southern living in Florida, you must travel to the north to find "the South." This is still true today, as those living in the northern third of the state generally speak with a regional southern dialect and often tend to share the ideas and characteristics attributed to residents of the neighboring states of Alabama and Georgia. This is in contrast to those residents of south Florida who, in general, have migrated from states in the North.

This chapter concerns an unusual era in the history of Florida and the United States when each influenced the other in significant ways and when the differences between northern and southern Florida were notable.

From the time the Florida territory was ceded by Spain to the United States in 1819 until the end of the Third Seminole War in 1859, the southern two-thirds of the Sunshine State was a battleground. The pirate war was waged on the seas and on the land in the south, and in the north, the Seminole Indian Wars were taking place. In effect, this meant that there was no peaceful area in central or south Florida for Americans to settle until 1859, the same year John Brown raided the federal arsenal at Harpers Ferry, Virginia, in a prelude to the American Civil War.

Historically, the Florida territory had featured little government and was afforded a freedom that didn't just encourage piracy. The lack of government authority also offered sanctuary for runaway slaves from the South, as well as to Native American Indians who were driven from their ancestral homes. The United States and Spain were at odds over Florida almost immediately

after Spain regained the territory from England in the Treaty of Versailles in 1783. Spanish and British privateers, as well as other Caribbean pirates, were trading and supplying goods to the Seminole Indians, who were in conflict with Americans trying to settle in northern Florida.

In December 1817, while Florida was still a territory of Spain, Andrew Jackson led an illegal invasion over the border in an incident that became known as the First Seminole War. President James Monroe had ordered Jackson to lead a campaign in Georgia to terminate the conflict between settlers and the Seminole and Creek Indians. Jackson was further charged with preventing Spanish Florida from becoming a refuge for runaway slaves. Jackson, with his Tennessee Volunteers, decided to invade Florida, capturing Pensacola and deposing the Spanish governor. He also captured, tried and executed two British men who had been supplying and advising the Indians.

Andrew Jackson, a slave owner and Indian hater, was ruthless in battle and earned the Seminole nickname "Sharp Knife." Spain protested this illegal international incident, but Secretary of State John Quincy Adams defended Jackson's actions and declared that Spain must either place a military force in Florida or cede the territory to the United States. It followed that the free territory of Florida was therefore ceded to the United States in 1821. Strangely enough, Andrew Jackson, perhaps the least popular and most despised man in early Florida history, was then appointed the military governor of Florida, serving from March 10, 1821, to December 31, 1821.

The status of runaway slaves continued to be an irritant between the Seminole Indians and white settlers and citizens. Seminoles and slave catchers argued over the ownership of slaves, the Seminoles believing that the slaves should be free. Many Americans advocated exterminating the Seminole Indians, often claiming crimes by the "savages" that either never occurred or were possibly committed by whites dressed as Indians.

When running for the United States presidency in 1828, Andrew Jackson had offered as one of his campaign promises the ethnic cleansing of several Indian tribes. This was a relevant issue with Jackson, since prior to the campaign, he had been negotiating treaties and removal policies with Indian leaders. His opponents in this presidential campaign referred to him as a "jackass," but Jackson liked the name, so he used the donkey as his symbol. After it was popularized by cartoonist Thomas Nast, the jackass later became the symbol for the Democratic Party.

In 1830, Andrew Jackson began to make good on his campaign promises with the Indian Removal Act of 1830. This legislation, authorized by a

Andrew Jackson. *Florida Archives.*

compliant Congress, allowed the president to negotiate treaties with the Indians that compensated them for their land and removed them to the west. All Seminole problems were now to be solved by transferring them west of the Mississippi River. After many Seminoles resisted relocation, the Second Seminole War began in 1835. It was the most expensive Indian war fought by the United States.

From the Southern Gulf Coast to the Keys and Beyond

Seminoles' attack on settlers sparked the Second Seminole War. *Florida Archives.*

With the pirate war concluded, the U.S. Navy could take a larger role in this conflict. The Mosquito fleet, part of the West Indies Squadron that had served in the pirate war, was a joint army-navy force of two hundred men that operated along the coast of Florida. The fleet included offshore schooners and barges, and it also sent sailors traveling in canoes up the rivers and streams of Florida, even into the Everglades. Close to the shore, its main purpose was to intercept Cuban and Bahamian traders (considered pirates by the U.S. Navy), who continued to bring arms, ammunition and other supplies to the Seminoles. The fleet established a base at Tea Table Key in the Florida Keys, but in spite of this joint force, the Seminoles were nearly impossible to find, as they hid in the Everglades.

The Second Seminole War ended in 1842, with the assumption that the remaining Seminoles would either go west or move to the reservation in southwest Florida. In the same month, the U.S. Congress passed the Armed Occupation Act, which provided free land in Florida to those settlers who improved the land and were prepared to defend themselves from Indians. More than 210,720 acres were registered to new owners from 1842 to 1843. In 1845, Florida became a state. These events only ensured that another conflict would occur with the Indians, whose lands had been seized. Adding to their bitterness was the manner in which President Jackson had handled the exportation of the Seminole and later Cherokee Indians with the "Trail of Tears" that led to Oklahoma.

The Third Seminole War occurred from 1855 and was declared over on May 8, 1858, after 163 Indians were shipped out of Florida. More were sent west the next year, although some Seminoles remained in the state. With the removal of most of the Indians, the small population of white settlers who were confined mainly to the northern part of the Florida remained divided on the issues that brought on the Civil War. The Sunshine State was now primed to have an intrastate conflict of its own within a national civil war.

Seminole Indians attacking Florida settlers. *Florida Archives.*

Cagey Seminoles hide from advancing troops. *Florida Archives.*

From the Southern Gulf Coast to the Keys and Beyond

A Civil War sea battle off east coast of Florida. *Florida Archives.*

Piracy or privateering is about freedom, power or financial gain, and we have learned that what constitutes piracy to one nation may be referred to as "privateering" by another employing nation. Following is an examination of a unique form of privateering that was a part of our history.

Following the election of Abraham Lincoln in 1860, Florida was the third state to join seven other Southern states in forming the Confederacy. With its small population and long coastline, Florida's role in the war involved contributing goods, producing cattle and other sources of food and providing ports. These ports were to be used by blockade runners, considered privateers and pirates by the U.S. government, who smuggled supplies, materials and weapons from foreign markets to the Confederate states.

Many foreign governments secretly or overtly supported the Confederate states in our country's Civil War. There were at least two clear reasons for this action: first was the Monroe Doctrine, which opposed "interference" by European nations in the Western Hemisphere. Second, there had been a pattern of retaliation toward many European and Mediterranean countries. A realist, President Abraham Lincoln proclaimed the blockade of the South on April 19, 1861, as one of his first acts during the Civil War. His strategy was part of the Anaconda Plan designed by General Winfield Scott, which required the closure of 3,500 miles of Confederate coastline and twelve major seaport cities. The plan was so nicknamed because it resembled the coils of an anaconda snake suffocating its prey.

As the Anaconda Plan was being organized and implemented to squeeze the South, Union officials viewed the numerous lighthouses along Florida's Atlantic and Gulf Coasts as particularly vulnerable to Confederate attack. The loss of shore lights for even a single night could be disastrous. Their fears were justified in August 1861 when the lighthouses at Jupiter Inlet and Cape Florida were made inoperable. Federal officials branded the attackers

Snake cartoon showing the blockade of Florida. *Florida Archives.*

as "a gang of pirates" and recommended that more measures be adopted for the lights on the reef.

The United States government commissioned 500 ships for the Anaconda Plan. These vessels succeeded in destroying 1,500 blockade-running boats over the course of the Civil War. However, 5 of every 6 ships evading or running through the blockade were successful, earning a vast amount of money for the privateers.

Most of the blockade runners were newly built ships with small cargo capacity but capable of high speeds and maneuverability. Many were constructed in foreign ports, primarily England, and transported supplies between the Confederate states and the neutral ports of Cuba, the Bahamas and Bermuda, where British suppliers had set up supply bases.

The CSS *Florida* was one of these ships. The *Florida* was a screw cruiser of about seven hundred tons, built in England in 1862. Operating in the Atlantic, the Gulf of Mexico and the West Indies, the *Florida* captured twenty-two prizes, striking terror in the United States Merchant Marine and frustrating the U.S. Navy. The *Florida* assisted many blockade runners

Left: Cape Florida lighthouse. *Florida Archives.*

Below: Florida, as part of the CSA, operated to aid blockade runners. *Florida Archives.*

in successfully completing their missions by occupying the Union ships on blockade patrol.

Wars generally make large sums of money for a minority of those involved. The American Civil War was no different, and privateering generated a good profit to the investors who provided the ships. It is estimated that British investors spent the equivalent of $250 million building and equipping the blockade runners. That amount is equivalent to nearly $3 billion in the present time.

The crews of the blockade runners, like many of the Golden Age pirates before them, earned great amounts of money when compared to the sailors serving in the national navy or commercial merchant ships. Many British Royal Navy officers took leaves from the British navy to captain or serve as

officers on board these blockade runners. They could make thousands of dollars payable in gold for completing only one round trip, and the crew members might earn several hundred dollars per voyage.

To counteract this and to man its blockade ships, the North had to enhance the potential earnings of United States sailors willing to serve on blockade duty. Therefore, like the enemy privateers, these sailors were also offered a substantial amount of money, as well as an improved quality of life on board the vessels. Blockade service became attractive to seaman and land dwellers alike. Although it was often boring, the food and living conditions on board the blockade ships were better than those of the land-based infantry, and there was less danger. The biggest attraction, however, was the share of the income that resulted from a captured blockade runner being sold at auction. The blockade ship crews were entitled to share in that income. About $25 million in prize money was awarded to blockaders during the Civil War, meaning that a seaman could make as much as $1,000 per captured vessel, and even teenage cabin boys might earn $500. This was at a time when army infantry pay was $13 per month.

During the American Civil War, the blockade runners, or privateers serving the Confederate States of America, stowed rifles, ammunition, medicine, brandy, lingerie and coffee from the ports of Havana, Nassau and the Bermuda Islands and sailed through the blockade to offload their ships at a Southern port. The trip might be from five to seven hundred miles. They would then load cargo such as cotton, turpentine and tobacco for the return trip. The blockade runners charged $300 to $1,000 per ton of cargo, meaning that two round trips per month would generate $250,000 income, with $80,000 being paid in wages and expenses. A net profit of $170,000 per month meant that newly constructed ships could be paid off in a very few trips. This proved a profitable enterprise for both the British investors and the crews of the privateers.

When the southern seaports of New Orleans and Savannah were blocked as a result of the Anaconda Plan, some tactics of blockade running changed. Blockade runners began loading shiploads of cattle and needed supplies at ports along the west coast of Florida and then sailing with these supplies to the Southern states. As the war progressed and even more major seaports of the South were blocked, the inlets and harbors of Florida became important to the blockade runners. This, in turn, changed the overall direction of the war, and resulted in a second civil war taking place within the state of Florida. In fact, Fort Myers, the county seat of Lee County, was actually born as a result of the Florida civil war.

 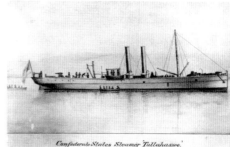

Confederate States Steamer Tallahassee.

Left: A privateer blockade runner. *Florida Archives.*

Right: A Confederate privateer chased by a U.S. Navy steamer. *Florida Archives.*

As already mentioned, Abraham Lincoln's naval blockade began on April 19, 1861, and from that point on, the privateers serving the Confederacy were known as blockade runners.

When Lincoln launched his plan to cut off Rebel ocean trade, no one could have envisioned that the Union's East Gulf Coast Blockading Squadron would be instrumental in creating a second intrastate civil war within Florida. Along with its allies, the refugees and escaped slaves, it would be one of the more active foes of the Confederacy in Florida.

Although Fort Pickens in Pensacola, Fort Jefferson in the Dry Tortugas and Fort Taylor at Key West remained Union forts throughout the Civil War, the blockade runners were initially successful in supplying the Confederacy. These privateers transported needed supplies to the Confederates and took back cotton and tobacco crops on the return voyages, making sizeable profits for the crews and owners of these ships. As noted, five out of every six blockade runners were successful in delivering their cargoes to the Confederates.

However; the East Gulf Coast Blockading Squadron took advantage of three factors to begin a civil war within Florida. First, there was now a limited nonnative population in southwest Florida since the Third Seminole War had recently ended. Much of the military action during that war took place on the Peace, Kissimmee and Caloosahatchee Rivers and the Big Cypress Swamp, so the area around Charlotte Harbor had been open to white settlement for only three years before the start of the Civil War. Secondly, forts that had been built during the Third Seminole War, although abandoned and stripped of most buildings, were still in existence and could be used to house troops and refugees. The third factor was that southwest

Florida's limited non-Indian population consisted primarily of refugees from the Civil War, deserters from the Confederacy and contrabands, or former black slaves, meaning that this unique population was opposed to the ideals of the Confederate states and was, therefore, an important source of manpower for the Union navy.

To inspire and lead this unique group of refugees and contrabands to fight for the Union cause, the U.S. Navy chose Henry A. Crane, who had been a printer and Florida military officer during the Seminole War. He resided in Tampa and, in the opening days of the Civil War, for "the purpose of home defense," had formed the Silver Grays, a group of older military men who also lived in Tampa. Crane refused a commission as lieutenant colonel in the Confederate army, since he could not bring himself to fight against the Union. He became a refugee in his own state when he left his wife and daughters in Tampa to join the Union cause. His only son joined the Confederate army, which made his family a house divided, a common occurrence during the American Civil War.

Henry Crane initially led inland military action on the east coast of Florida, harassing the Southerners and destroying Confederate property. He then returned to western Florida and was stationed aboard the USS *Rosalie* in Charlotte Harbor. Crane also brought a number of refugee families who were Union sympathizers to Charlotte Harbor to settle on Useppa Island under the protection of the Union navy. These refugees provided valuable information to the Union navy and also became boat pilots, guides and even fighters for the North. Since the refugees were from Florida, they could often provide the identity of fellow Floridian blockade runners to the Union navy.

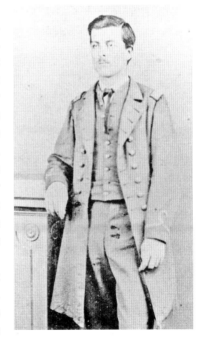

The first post of refugee soldiers at Fort Myers was established by Henry Crane. On January 3, 1864, Crane led two boats from Punta Rassa up the Caloosahatchee River to a deserted former army post, Fort Myers, which had been built before

A Confederate privateer sea captain. *Florida Archives.*

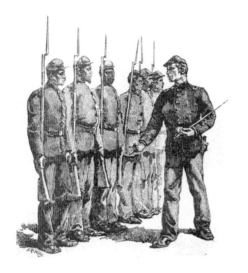

Above: Confederate steamer *Tallahassee* protected blockade runners. *Florida Archives.*

Left: U.S. Fort Myers soldiers during the Civil War. *Florida Archives.*

the Third Seminole War. General Woodbury, Henry Crane's commander, along with members of the Forty-seventh Pennsylvania Volunteers, came to Fort Myers to recruit refugees and former black slaves to defend Fort Myers. Woodbury also moved his military base for operations from Useppa Island to Fort Myers because Useppa was too dependent on water transportation to operate at maximum advantage.

Henry Crane was named commander of Fort Myers and was transferred from the Union navy to the United States Army as a captain. Crane and his 170 former black slaves became known as the Second Infantry Regiment, U.S. Colored Troops, and served the Union well. Their presence also gave notice to the citizens of southwest Florida that the Union army was there to stay. These troops raided and harassed cattle shipments, causing significant disruption in the area. Those actions limited any future successes of the local blockade runners for the remainder of the Civil War.

Fort Myers was a functional fortress until after the end of the Civil War. When it ceased to operate, a number of the people remaining formed a nucleus for the present-day historic and vibrant city. All this was due to the intrastate civil war fought to control the supply sources of the Confederate privateer blockade runners.

Coastal blockade battles took place around most of the Florida coastline. The USS *Sagamore*, under Captain English, was one of the most successful naval ships off the east coast of Florida. Other Florida blockaders included the sailing ships USS *Stonewall* and USS *James L. Davis* and the steamer USS *Sunflower*.

In the decades since the Civil War, the 1,380 miles of coastline that surround Florida have seen pirates, privateers, crime syndicates and independents turn into smugglers of nearly every commodity known to man. Many of the tactics employed are the result of the lessons learned during the American Civil War. At times, this activity has occurred when the federal or state government has enacted laws that are not supported by the population as a whole.

From Civil War to Prohibition

During the Civil War, Florida was not ravaged to the extent of several other Southern states. Although some Union forces occupied coastal towns and forts, the interior of the Sunshine State remained in Confederate hands. In fact, Tallahassee was the only Southern state capital east of the Mississippi River to avoid capture during the war. Immediately following the conflict, many of the same privateers who had been blockade runners began selling their transportation services to those who would rebuild the South. This rebuilding was called Reconstruction.

As was the case during the war, Florida's provisions of lumber, cotton, vegetables, oranges, salt and beef were needed in the South. These supplies were primarily shipped on the water due to the destruction of railroads and bridges in most other Southern states. Large sums of money were available from the government for shipping these products. And as a bonus to private ship owners, the overseers of these vast amounts of money were sometimes sincere but more often unscrupulous "carpetbaggers" sent from the Northern states to oversee Reconstruction.

"Carpetbaggers" was a pejorative term most Southerners gave to these Northerners, or "Yankees," who moved south between 1865 and 1877 during the Reconstruction era. The carpetbaggers used inexpensive luggage constructed by saddle makers, often from used pieces of carpet. These bags were sold in dry goods stores for one or two dollars and during the 1860s were carried by nearly everyone. An individual could be identified as a traveler or outsider when seen with his carpetbag.

During the period of Reconstruction, the economy of Florida, as well as the other Southern states, underwent a transformation. Now land was allotted and turned over to impoverished African American tenant farmers and sharecroppers, replacing the earlier aristocratic plantation system. Most Reconstruction programs were not effective in spite of the massive amounts of money invested. Florida, arguably the oldest territory in North America, needed to reinvent itself once again.

During the final quarter of the nineteenth century, Florida agriculture began to return a profit when large-scale commercial organizations bought the jigsaw puzzle of small farms that had been created at the end of the Civil War. Cattle ranching became one of the most important agricultural industries, second only to that of Texas in scope. Cigar manufacturing took root in the immigrant communities of the state, particularly Key West and Tampa. The formation of the tourism and hotel industries came with the advance of the railroad into Florida. The railroads also were instrumental to the development of citrus farming and phosphate mining. A vital fishing industry, along with sponge harvesting in Tarpon Springs, contributed to the growth of Tampa and Boca Grande as active seaports. Many ships were now servicing the new industries, and more lighthouses were necessary along the southwest and west coasts of Florida.

These fledgling industries needed laborers, and Florida did not have enough citizens to provide manpower for all of the new jobs. In contrast to other states, where unemployment was sometimes a problem, Florida needed workers for its industrialization and development. National immigration policy of the period, however, was not favorable for the recruiting of these individuals from foreign countries. The Chinese Exclusion Act of 1882, in particular, banned the entry of Chinese laborers into the United States. It also allowed deportation of laborers who had entered the United States illegally. Because of these policies, another form of piracy developed: the smuggling of human beings, illegal immigrants from other nations.

In the years following the Civil War, as in eras before, smugglers took full advantage of the shallow waters, deserted mangrove islands, inlets and even the swamps of Florida to carry on a variety of illegal pursuits. It wasn't just liquor, drugs, arms and other commodities that were being smuggled into Florida; the smuggling and trafficking of human beings also became profitable enterprises. Since the immigration laws were a detriment to the manpower shortage in Florida's burgeoning industries, they often lacked the support of the residents.

Boca Grande Lighthouse. *Florida Archives.*

Both smuggling and trafficking are ways of illegally bringing people into a country other than their own, and both are financially rewarding to the supplier, but there is a difference. Smuggling occurs when both parties (the person being transported and the smuggler) are in agreement, and there is usually a financial contract between the two. Human trafficking involves the transportation of individuals from one place to another, sometimes for illegal purposes and either against their will or under false pretenses.

The pirates who smuggled people into Florida, particularly from Cuba, during the period of 1875–1920, had rich financial rewards. A *New York Times* article published on November 30, 1902, had as its headline, "Havana Boatmen Smuggle Chinese." The story reported how Chinese men evaded the Chinese Exclusion Act by paying Cuban fisherman to carry them across the gulf and land them in an isolated part of the Florida coast.

The Florida smugglers of this period also often became the "rumrunners" of the Prohibition era. The Eighteenth Amendment to the Constitution of the United States was perhaps the most unpopular law ever enacted in the country, and it was not supported by the majority of the people. It began in 1920 as the "noble experiment" and became a colorful, sordid and ignoble chapter in Florida and the nation's history. Prohibition led to the development of the Florida rumrunners, the 1920s version of the Civil War blockade runners. Initially, this illegal importation of alcohol took place more actively on Florida's

Florida smugglers during prohibition. *Florida Archives.*

east coast. The population centers there were denser, and there were more airstrips and airplanes, both government and chartered private aircraft, to provide the opportunity for smuggling alcohol.

Soon the favorable geographic features of the more isolated southwest Florida coastline attracted the many schooners, motorboats and freighters illicitly importing spirits. The area became a receiving point for Cuban rum or British Scotch from the Bahamas. Like the human smuggling and, later, drug smuggling and human trafficking, rumrunning was a very profitable venture. As an example, a rumrunner could legally buy a case of Cuban rum in Cuba for $4 per case and sell it in Florida for more than $100. Since many rumrunners "cut" or watered down the beverages and rebottled them, the profit margin exploded beyond that number.

Although smugglers had to be concerned about the United States Coast Guard, they also had to worry about other smugglers. These other pirates, often more unscrupulous, might not just steal their cargo at sea or on the shore; they might also deliver the smugglers to the bottom of the sea in a "cement overcoat." The thievery of illegal liquor and weapons meant easy money to the pirates of these turbulent and financially difficult times. Prohibition ended with the repeal of the Eighteenth Amendment in 1933.

Many terms or phrases we now use in daily conversation have their roots in the piracy, smuggling, rumrunning and other illegal pursuits of this time. The phrase "belling the cat" can be ascribed originally to a fable, but another version became popular during this period when large freighters or "mother ships" remained legally offshore. Their illegal cargo was distributed to smaller boats or "runners" that ran it to the shore. If a Coast Guard boat was patrolling the area, the first runner would pretend to offload from the mother ship and then lead the Coast Guard vessel away from the area in a pursuit. The pursuer usually stopped the first boat successfully, only to be shown empty boxes or no cargo at all. While the Coast Guard boat was occupied in pursuing the first runner, another went to the mother ship, stowed part of the authentic cargo and took it to shore by another route. "Belling the cat" is a tactic still employed today, particularly by drug smugglers.

Captain Bill McCoy was born in Syracuse, New York, in 1877. His father had served in the U.S. Navy aboard a blockade ship during the Civil War. Bill graduated at the top of his class from the Pennsylvania Nautical School in Philadelphia and then also served in the U.S. Navy as a mate. He was aboard the anchored USS *Olivette* at Havana, Cuba, on February 15, 1898, when the USS *Maine* exploded.

The McCoy family then moved to Holly Hill, Florida, and operated boatyards in both Holly Hill and Jacksonville. By 1918, Bill McCoy and his brother, Ben, were both skilled boat builders who constructed vessels for Andrew Carnegie, the Vanderbilts and other millionaires of the day. During prohibition, the McCoys turned to the profitable business of smuggling rum. They sold their assets in Florida and traveled to Gloucester, Massachusetts, where they bought the schooner *Henry L. Marshall*. Bill then founded "Rum Row," which consisted of a chain of ships along America's eastern coast extending from New England to the tip of Florida. These mother ships provided rumrunners illegal alcohol to be smuggled ashore in smaller boats. Bill McCoy eventually made enough money to purchase five more vessels. He renamed one of these ships *Tomoka*, after the river that ran through his hometown of Holly Hill, Florida. McCoy was an exception to most other alcohol dealers because he refused to water his liquor or rebottle cheap Cuban rye and give it an expensive label. His rumrunner business associates agreed to steer customers in search of quality liquors to Bill McCoy since he attained a reputation for selling only the finest alcoholic beverages. The phrase "the real McCoy" may have other antecedents as well, but it is now a part of our everyday language. One odd fact is that Captain McCoy was a self-confessed teetotaler who never consumed alcohol.

Another, more infamous, liquor pirate was from southwest Florida. James Horace Alderman, the "Pirate of the Gulf Stream," was born on June 24, 1883, in Hillsborough County, but his family moved to the Ten Thousand Islands when he was a child. In his younger years, he gained the reputation as a skilled fishing guide for President Teddy Roosevelt, Zane Grey and other notables in their quest for tarpon. These experiences aided Alderman in learning the intricacies of the southwest Florida coast.

Horace Alderman married Pearl Robinson of Lee County on April 8, 1906, in Fort Myers, Florida. After his marriage, he ran a poolroom. It served as a rendezvous for those who were high-stakes gamblers among the pioneer cattlemen of the Everglades. Before prohibition, Alderman was involved in numerous illegal nautical adventures along the southwest Florida coastline. Usually these involved smuggling Chinese and other nationalities from Cuba into Florida at both Punta Rassa in Lee County and Chokoloskee Island in the Ten Thousand Islands. He was accused of killing at least seventeen of his Chinese customers by throwing them overboard between Cuba and southwest Florida after receiving a large payment for the transport. Legend claims an even higher death toll.

James Horace Alderman, liquor pirate. *Florida Archives.*

With the passage of the Eighteenth Amendment, even more money could be made in transporting liquor, so Alderman became a rumrunner. During his early days of smuggling liquor from the Bahamas, he made the mistake of employing a customs agent as a cook on his boat. Alderman was arrested and convicted, serving one year and one day for this infraction. He then returned to full-scale smuggling of both liquor and aliens until the Coast Guard captured him thirty-five miles southwest of Miami on August 27, 1927, with fifty containers of illegal whiskey. Alderman was taken on board the Coast Guard cutter, whereupon he drew his pistol and killed two Coast Guardsmen and a Secret Service man. He briefly took control of the cutter, threatening to burn it and kill the rest of the crew, but was subsequently subdued and taken to the Coast Guard base at Bahia Mar in Fort Lauderdale on the east coast. James Horace Alderman had previously been declared a pirate in Broward County and was now convicted of murder in Dade County. Since maritime law decreed that a pirate be hanged at the port where lawmen first brought him, James Horace Alderman was hanged in a seaplane hangar at Bahia Mar in Fort Lauderdale on August 17, 1929. He is one of only two federal prisoners ever executed in Florida.

Another southwest Florida rumrunning smuggler was "Wicked" Frank Lowe, a pirate who initially operated from the Bahamas. Frank Lowe was born near Charlotte Harbor in 1891 and was unique in that he built his own swift boats to outrun the Coast Guard cutters, unlike current smugglers who steal fast boats to ply their trade. Like James Alderman, Frank smuggled both liquor and Chinese immigrants into the United States from Cuba. And also like James Alderman, Frank Lowe allegedly murdered many of the Chinese immigrants who had paid him to take them to southwest Florida. Many people also believed that Frank Lowe, along with some of his fellow smugglers, murdered Collier County sheriff's deputy J.H. Cox, his wife and their two children. Frank Lowe certainly earned his nickname.

In most cases, when rumrunning liquor pirates were captured, the public would not convict them even of murder. A story from Loren "Totch" Brown,

The hanging of a liquor pirate. *Florida Archives.*

one of Florida's most colorful characters from the Everglades, related that during the bootlegging days there was plenty of available whiskey due to rumrunning from the Bahamas to the Ten Thousand Islands. It was carefully repackaged into tomato crates, loaded onto a truck and driven to the Atlantic Coast Line train station in Everglades City. From there it was shipped by train disguised as tomatoes. An FBI man named Hutto came to town one day to investigate and jumped onto the truck's running board as it was transporting the crates. The driver reached out the window, grabbed Hutto's gun and fatally shot him. A trial was held locally, and the driver was found innocent of all charges.

As we have discovered, any time that overly restrictive laws are passed, there is an opportunity for money to be made. The Florida rumrunners are an example of opportunists willing to take risks to supply desired products. This often endowed them with an aura of bravado and rekindled the public's romantic ideas of pirates, particularly when these pirates broke laws that were not supported. This romantic image carried into the future to the "Square Grouper" drug smugglers, often also called "Saltwater Cowboys," and the subsequent "Cocaine Cowboys" who followed the era of prohibition in the waters around Florida.

From Prohibition to Present Day

When the profit was taken from rumrunning by the repeal of the Eighteenth Amendment on December 5, 1933, illegal importing of liquor drastically declined. After prohibition and before World War II, however, it was replaced by gun smuggling. Arms were sent to Central American countries from Florida, with narcotics coming on the return trip. Many of the ex-rumrunners, therefore, had another avenue for their pirate activity.

During World War II, many German spies were transported by German submarines to deserted areas of the southern Florida coastline and thus smuggled into south Florida in order to learn military secrets. They were trained to blend with the many American servicemen training at bases throughout the state. Unlike human smuggling before and after the war, Americans did not participate in or profit from these illegal activities due to their patriotism.

The United States' political leadership has always had an intense aversion toward the institution of communism, sometimes to the point of assuming a communist conspiracy when it is not a real threat. While fighting Nazism and fascism during World War II, the Office of Strategic Services (OSS), the forerunner of the Central Intelligence Agency (CIA), began to quote an old adage about "making deals with the Devil" in connection with a possible communist takeover in China, Italy and France.

The "globalization" or "multinational" business of drug trafficking can be traced back to these deals. They began shortly after World War II when

the United States intelligence agency, first as the OSS and then as the CIA, made agreements with the Chinese government of Chiang Kai-Shek and the Burmese government. The purpose of the deals was to bolster and support the right-wing regime of Chang Kai-Shek so that it would not fall to the communists. Heroin was grown in Burma, processed in China and then shipped to the United States, where it was sold in the ghettos. The revenue gained from these transactions was used to buy the arms sent back to China.

When the communists took over China and eliminated drugs, the CIA made agreements with the Corsican mafia syndicates in both Italy and France to illegally export heroin to the United States. It was given to the American mafia and continued to be distributed in the ghettoes. The sale of these drugs raised money not only for United States' continued efforts against the spread of communism in Italy and France but also for the members of the mafia, who became the clandestine enforcers of CIA anti-communist policy. The CIA felt that it needed to rely on the mafia to help suppress the growth of communism.

The oceangoing smugglers of Florida were now able to return to business on a much expanded and financially rewarding basis. The renowned gangster Lucky Luciano was released from prison in New York in 1946. He traveled to Italy, where he formed strong ties between the former Genovese mafia and the Marseilles syndicate of France. He then had raw opium imported from the Middle East and processed into high-grade opium in Italy. The powerful heroin derived from this opium was sent to Marseilles and from there shipped to Cuba. This became known in drug circles as the French Connection.

Lucky Luciano's chief deputy was the notorious criminal Meyer Lansky, who contacted Cuban dictator Fulgencio Batista. He made an arrangement with Batista whereby the mafia would be given a monopoly on Cuba's flourishing gambling industry. There were also assurances that Sicilian heroin could be shipped from Marseilles to Havana and then on to the United States. In return, Batista and his assistants were to receive half of the profits from all the Cuban casinos. These deals gave Batista the potential of great wealth.

Lansky and Luciano chose Sicilian-born Santos Trafficante of Florida to run the gambling and drug business. Drug-running pirates smuggled the narcotics from Cuba to Miami, as well as other ports in Florida.

Coincidentally, after World War II, the federal government changed the Coast Guard's primary responsibility to aiding navigation and safety at sea. This, in effect, gave a free pass to smugglers operating into and out of

Florida. This limited enforcement role lasted until the Cuban revolution of 1959, when Fidel Castro and the communist party took control of Cuba and tossed out the mafia. The CIA, by then derisively called "Cocaine Importing Agency," moved its drug operations to southeast Asia. The United States Coast Guard could once again take on the responsibility of stopping the smuggling of men and weapons as part of its mission.

Unfortunately, during this time, both the influence of the staggering amounts of money earned from smuggling drugs and the large number of addicted drug users created a climate for drug smuggling that exists to this day in the United States.

During the period of the late 1960s through the early 1980s, smugglers in southwest Florida brought in tons of marijuana wrapped in bales that were called "Square Grouper." This point of entry became necessary when the Cubans and Colombians living in Miami were engaged in the Miami Cocaine War to determine which group would control the drug traffic. The places of entry for most of the marijuana coming into Florida from South America shifted to sparsely populated areas of Collier County and the Ten Thousand Islands. Again, freighters anchored offshore to serve as mother ships, this time loaded with marijuana. The drug was loaded into smaller boats piloted by local fisherman and crabbers who, in most cases, simply could not resist the lure of supplementing their meager incomes. These "Saltwater Cowboys" knew the treacherous waters offshore and were able to successfully ferry the marijuana to shore through the numerous mangrove-covered islands. On most nights, between fifteen and fifty tons were offloaded just on Chokoloskee Island. The locals could earn between $15,000 and $75,000 working only one job. As the amount of the smuggled goods increased, that income could soar to between $500,000 and $1,000,000. "We were like good pirates, good ole boys not hurting anyone and making more money than we could imagine," one Saltwater Cowboy remarked.

A federal crackdown in the mid-1980s in Everglades City and Chokoloskee, dubbed "Operation Everglades," resulted in the seizure of dozens of boats and vehicles, at least $252 million in marijuana and the sentencing of many local smugglers. Most of the Saltwater Cowboys served their prison time, returned to their roots or retired from the trade and then lived comfortably.

Following the entry of marijuana into south Florida, cocaine became the most smuggled drug, and south Floridians plying this trade soon became known as "Cocaine Cowboys."

Drug interception became an increasing emphasis for the Coast Guard in the early 1970s, and it remains a major focus today. The illegal or

The Coast Guard makes a large drug bust. *U.S. DEA photo.*

nonprescribed use of drugs has been a factor in society for most of history. Currently, millions of dollars are spent annually to enforce existing drug laws. In the United States, citizens desiring to use these banned drugs spend $65 billion every year to purchase them. The United States is the largest consumer of drugs in the world.

The state of Florida in general, and south Florida in particular, is a primary area for international drug trafficking and money laundering organizations, as well as a principal thoroughfare for cocaine and heroin transiting to the northeastern United States and Canada. The increase in the price of shipping drugs through Mexico, as well as increased efforts by United States federal law enforcement on the southwestern borders of the United States, has brought the Colombian cocaine smugglers back to their traditional routes through the Caribbean and into Florida.

The drugs currently smuggled into south Florida include crack cocaine, heroin, methamphetamine and other club drugs, as well as the "pharmaceutical diversion" of prescription drugs sold illegally on the Internet. Marijuana is still imported, but domestic indoor cultivation is now a significant industry in Florida, with nearly every community having discovered "grow houses" in residential neighborhoods.

Like the rumrunners of the past, traffickers rely on "go fast" boats to smuggle cocaine. These boats are of custom fiberglass and have eight-hundred-horsepower engines. Besides achieving speeds of fifty miles per hour, they also utilize global positioning systems, satellite telephones and other high-tech devices to provide a seamless cocaine delivery system to the United States.

In addition to the fast boats, the drug cartels have constructed semisubmersible submarines in the jungles of Colombia. They are not submarines in the traditional sense, as the crew and engines need fresh air, though in some instances they can be operated by remote control. The subs operate in shallow water and can be towed to such an area. Each costs between $1 million and $2 million to build. These semisubs are between forty-five and eighty feet in length and cruise at a top speed of about six knots. They are made of steel, wood and fiberglass, are powered by one or two six-cylinder diesel engines and displace about six feet of water. The subs offer room for a crew of three to four people and can hold about ten thousand pounds of cocaine. They are termed "semisubmersible" since they do not go completely underwater, but extending only about twelve inches above, they can't be monitored by any standard radar detection capability. Typically, they must be observed from the air to be seen.

Modern ships and planes patrol the Florida coast. *USCBP photo.*

From the Southern Gulf Coast to the Keys and Beyond

To counter both the drug and human smuggling and human trafficking, the government also employs a fleet of fast boats, as well as helicopters and fixed-wing aircraft.

Smuggling people into the United States is a very profitable enterprise that again uses mother ships and fast boats. Large sums of money are exchanged for this illegal transport of humans into the country. In addition to smuggling, south Florida has become a key area of concern with regards to human trafficking in the Western Hemisphere. This has resulted in heavier patrols of the Florida Keys. To avoid the patrols around Miami and in the Keys, smugglers and human traffickers have elected to enter the United States on the southwest coast of Florida or the Atlantic Ocean coastline north of Fort Lauderdale. Individuals wishing to be smuggled to American soil often pay $8,000 to $10,000. With this per capita amount of money to be earned, these areas are seeing greater thefts of expensive, fast, multi-engine boats from affluent coastal communities.

Collier County, for example, has hundreds of miles of coastline, thousands of uninhabited islands and limited federal enforcement agencies such as the Coast Guard, Border Patrol and Immigration and Customs Enforcement. After Cuban smugglers and other human traffickers pick up their Cuban migrants or other nationalities, it is an ideal area to deposit their human cargo and make a quick return to their local shores.

Collier and Lee Counties have also become more accessible terminals since September 11, 2001, when the U.S. Navy and other federal agencies strengthened border surveillance and detection efforts off the Florida Keys, making that area less attractive for the smugglers and human traffickers. Many of the current human smugglers bring their boats on trailers from the Miami area, launch them at local area boat ramps and marinas and complete their mission by traveling to the mother ship and bringing the illegal immigrants back to shore. They then return to the east coast of Florida with their human cargo and a large profit. To counteract this tactic, the various enforcement agencies work together to patrol inlets and bays in small shallow draft boats and watercraft such as a U.S. Coast Guard patrol boat.

Politics and immigration policy often create profits for those involved in human trafficking and human smuggling. Our current situation involving drug smuggling and human smuggling is in many ways similar to the prohibition days of the Florida rumrunners. The biggest supporters of prohibition were the local moonshiners who profited from the law. In today's world, we need to determine who benefits and profits by drug and

The Coast Guard patrols the shoreline and the bays. *USCG photo.*

human smuggling. Then we need to adjust our policies and laws to change the conditions. To solve these problems will take discussion, evaluation and possible changes in our drug and immigration laws instead of relying solely on law enforcement agencies that, by themselves, will not solve pirating on the coastline of Florida.

One approach might be to make drug laws more scientific, perhaps legalizing and taxing less harmful drugs in order to provide treatment to those individuals addicted to drugs, while at the same time maintaining continued prohibition of more harmful drugs. The effect of taking the massive profits away from drug dealers and also taxing them for permitted drugs is something to consider. The fact remains that piracy will always occur in some form, but frequently it occurs when massive amounts of money can be made in response to the politics, conditions and often restrictive laws of the times.

Even if we can change our immigration and drug laws, there is other smuggling occurring into and out of south Florida today. In 2009, criminal rings of foreigners and businesses were charged with illegally supplying electronic parts to Iran via south Florida. These parts were to be used for explosives that could target American soldiers.

The region has also expanded into a viable gateway for arms smuggling, not only to the traditional receiving countries of Latin America but also

to the Middle and Far East. One example of the magnitude of these arms transactions occurred in August 2004, when federal officials seized more than 700,000 rounds of ammunition and more than two hundred weapons destined for an overseas market. Just four years later, an even larger deal linking south Florida to the war in Iraq was uncovered.

Miami and south Florida will probably always be centers of illegal smuggling. Expensive illegal prescription drugs are pirated. There have even been unique cases involving illegal Freon refrigerant, cigarettes and even tropical fish and yellow fin tuna.

The pirates of today, like those of the past, are engaged in a quest for wealth, power and freedom from restrictions. About 95 percent of the world's imports and exports are now transported by ship with small crews operating them, thanks to modern technology. In some parts of the world, particularly in the Indian and Pacific Oceans, there is no shortage of targets for piracy. If Mexico, Florida's neighbor across the Gulf of Mexico, continues to have internal problems with its drug cartels and becomes a lawless state, we could see the same type of overt piracy in the Gulf of Mexico.

As we follow the history of piracy in south Florida, from the looting of ships in the early treasure fleets to the present, we must be aware that piracy did not just exist in the past. It still exists in the present and will no doubt continue into the future as long as the potential for financial reward outweighs the risks inherent in the enterprise.

As we have challenged students in our history classes, "always realize that in order to understand our future, it is necessary and vital to know our past history, both real and mythical."

Glossary

abeam: at right angles to a ship.

about: turn around, as in "come about."

aft: the back or stern of a vessel or ship.

ahoy: a call used in hailing or calling out to a ship.

aloft: up in the rigging.

amidships: in the center of the ship.

anchor: a heavy object, usually made of iron and shaped with flukes, attached to a chain and lowered into the water to keep a ship from drifting.

articles (as in articles of confederation): a contract signed by pirates before going on a voyage; the articles are the ship's rules and how each person will be paid or divide up any prize or booty.

"avast": simply means to "stop."

"aye, aye!": yes.

bail: to remove water in a bucket.

ball: a bullet or musket ball.

bar or sandbar: a sandbank or a shoal, often under shallow water, at the mouth of a harbor, bay or sound.

barrier island: an island lying parallel to shore separated by a sound of water.

bay: a wide inlet of water.

"belay there": to stop doing something.

bilges: the bottom of a ship's hold, almost always full of water.

blockade: shutting off a port or city to prevent anyone from getting in or out.

booty: a prize or cargo taken from a captured or sunken ship.

boucan: The cooking device used by buccaneers of Hispaniola to produce tangy smoked meat.

bow: the front part of a ship or boat.

bowsprit: a heavy spar that points forward from the bow of a ship.

brigand: a member of a band of men, usually pirates, who rob and plunder.

brigantine: a two-masted sailing vessel that can be rigged with either square or fore and aft sails; generally a shallow-draft hulled vessel that could sail in shallow or deep waters, avoiding capture.

broadside: 1. the simultaneous firing of all the cannons on one side of a ship at an enemy; 2. a large sheet of paper printed on one side and used to convey a political message or news, often posted on poles, trees and bulletin boards.

buccaneers: pirates who operated in the Caribbean and around the coast of South America during the seventeenth century—original buccaneers were hunters from what is now Haiti and the Dominican Republic; mostly French, they cooked their meat over open stoves in a process that was termed "boucaner," which gave these men their name.

bulkhead: wooden and later steel walls inside a ship to divide the ship and in the hold to keep cargo from rolling about.

bullion: gold or silver bars or ingots.

buoy: an anchored float marking a navigable channel or dangerous shallows.

cache: a hiding place for treasure; a hoard or store.

cannonade: a small cannon, sometimes on a swivel.

capsize: to upset or cause to flounder; to overturn or become overturned on water.

capstan: a barrel-shaped device used to weigh or raise the anchor.

careen: to intentionally beach a ship; to lay it over and remove the barnacles and seaweed from the hull.

cargo: the freight, goods, materials or luggage carried by a ship.

castellan: military officer in charge of a castle or a fort.

cast off: release dock lines; let go.

cat-o'-nine-tails: a whip with nine cords used for discipline or punishment.

caulk: to waterproof between the planks of the hull of the ship.

cobblestone: a rounded stone used as ballast in sailing ships and for paving streets.

colors: the flags flown on ships to show what country they come from.

commission: also known as a letter of marque, this was a document that authorized private citizens to wage war on a nation's enemy.

corsairs: pirates based in the Mediterranean Sea—generally of the Muslim faith; however, the corsairs of Malta were supported by Christians to fight the Muslim corsairs.

corsaro: a pirate.

Cowboys: a term given to the colonists who remained loyal to England for the way in which they robbed or stole livestock from the "rebels" or colonists fighting against England; the valuables taken or the livestock were sold or given to the British army.

crew: sailors who work on a ship.

crow's nest: a platform at the top of the mainmast used as lookout. During some periods, this is where actual birds nested. Each day they would fly off and, when not near land, would return later. When near land, crows or the other birds would simply not return, letting crews know that they were near land.

cutter: a single-masted sailing boat rigged fore and aft.

doubloon: a gold Spanish coin used in Spain and Spanish America.

fathom: a measure of six feet in length used to define the depth of water.

flotsam: the wreckage of a ship or its cargo found floating on the sea.

flukes: on dolphins, two adjacent, horizontal, flat appendages that act like paddles, propelling the dolphin through the water with every up and down flex of the tail muscle. Dolphins have been involved with human seagoers throughout history.

fore: the front part of a ship at the bow.

forecastle: the upper deck of a ship in front of the foremast.

founder: sink.

freebooter: someone who lives by plunder and loot, a word often used synonymously with "pirate."

frigate: a fast, three-masted, square-rigged navy ship carrying between twenty-four and forty cannons.

galleon: a large three- or four-masted sailing ship used from the fifteenth to seventeenth centuries, especially by Spain as both a warship and treasure ship.

galley: the kitchen of a ship; in older days, a long narrow single-deck ship powered by oars or a single sail.

gangplank: a moveable bridge used in boarding or leaving a ship at a pier or dock.

"gangway!": "get out of the way!"

gibbit: iron frameworks into which the tarred remains of pirates are hanged and left to rot on public display.

gunboat: a small but heavily armed vessel of shallow draft for patrol and for shore bombardment.

halyards: ropes used to hoist sails.

hawser: a rope, steel cable or chain used in mooring a ship.

heads: the ship's toilets.

"heave away!": "pull up the anchor!"

Hispaniola: the Caribbean island now divided between Haiti and the Dominican Republic whose historic pirates were called buccaneers.

hull: the frame or body of a ship, without sails or rigging.

immigrant: a person who immigrates to a new country or region.

Jolly Roger: A pirate ship's flag; can have either a red or black background with symbols of death, like skull and crossbones.

keel: a wooden bar extending beneath the ship, providing stability.

key: in the geographical sense, a reef or low island.

knot: 1 nautical mile per hour (actually equals 1.7 miles per hour).

landlubber or lubber: a landsman, someone who lives onshore.

landyards: ropes used to tie things.

larboard: the left side of the ship, looking forward; "port," in modern terms.

leeward: away from the direction the wind is actually blowing.

legend: a story handed down for generations among people and popularly believed to have a historical basis that is not verifiable.

letter of marque: a contract, license or a commission issued by a government authorizing private vessels to attack and capture all ships of an enemy nation.

longboat (ship's boat): generally, the largest boat belonging to a ship that is used to carry heavy items and crew members to and from the ship.

"look lively!": "shake a leg!"; move along briskly.

Loyalist (Tories): American colonists upholding the cause of the British Crown or remaining loyal to England during the American Revolution.

man-of-war: an armed warship, generally a large one, used by the navy of a country with a national navy.

marlinspike: a metal spike used to separate strands of rope for splicing.

mast: a long wooden or metal pole set up on a ship's keel or deck to carry a sail or other rigging.

"me hearties!": crew or shipmates.

merchant vessel (merchantman): a ship that transports goods and items used in commerce.

mutiny: open revolt against lawful authority, especially naval or military authorities.

New Spain: present-day Mexico.

New World: the lands located in what is now the Western Hemisphere.

pardons: in an effort to eliminate or control piracy, from time to time governments offered free pardons to all those willing to forego their villainous and pirating ways and become law-abiding citizens.

Patriots (Rebels): during the American Revolution, those colonists who declared their independence from England and fought to form a new United States of America.

piece of eight: a Spanish coin used throughout the American colonies during the time of the American Revolution (was actually our first currency); the term came from silver coins called cobs or pesos.

pillage: the act of taking goods by force.

pirates: men and women who loved freedom and robbed and plundered at sea and land to earn a living; believed in democracy and equality.

pod: a group of dolphins that live together.

port: the left side of a ship as you face forward toward the bow.

press-gang: to kidnap a man for service at sea.

privateers: armed privately owned ships, including the captain and crew, authorized by a commission or letter of marque by one country to attack and capture ships of an enemy country.

prohibition: in the text, the forbidding by federal law of the manufacture, transportation or sale of alcoholic beverages during the period of 1920–33.

quarter deck: a deck above the main deck at the stern (back) of the ship from where the captain and other officers control the ship.

quarters: living areas on board a ship.

ratline: ropes forming the steps of a series of rope ladders running from the hull of a ship up the different masts.

rigging: the arrangement of sails and masts on a ship and the rope work above deck.

roundshot: a cannonball.

rowboat: a small, shallow boat propelled by oars.

rudder: used to steer the ship.

salvage: items rescued or taken from shipwrecks.

scuppers: openings in or on the side of a ship that let the water drain away.

scuttle: to sink or attempt to sink a ship by cutting a whole in the hull.

sea anchor: a drag towed behind a ship to slow it down.

sea chest: a sailor's wooden box or chest that contains his belongings.

seafaring: working on a ship or traveling on the seas.

sea wall: a wall constructed to prevent encroachment by the sea.

"shiver me timbers!": "goodness!" or, "oh my!"

"sing out!": to call or yell out loud.

smuggle: to bring into or out of a country illegally; one who does this is called a "smuggler."

sound: to use a lead or metal weight on a rope or chain to determine the depth of the sea or water.

sounding lead: a sounding lead is a wire used to tell if waters are deep enough for a ship to pass safely without grounding.

Spanish Main: the Spanish-held mainland of North and South America.

spill: loose wind from a sail.

spit: a shoal or reef extending from shore; often a "spit of land."

splice: join two ropes or lines together by intertwining strands.

squadron: a naval unit consisting of two or more divisions and sometimes additional vessels.

squall: a sudden high wind, generally accompanied by rain or sea.

square-rigged: sails set at right angles from horizontal yards attached to a mast of a ship.

starboard: the right side of a ship as you face forward toward the bow.

stay: a rope supporting a mast on a sailing ship.

steamer: a ship driven by steam.

stern: the rear or back of a ship or boat.

swab the deck: to mop or scrub down the deck.

sweating: a ship's fiddler would strike up a tune, and the pirates would poke hapless victims with forks and daggers to keep him dancing and dancing until he either confessed or collapsed.

"sweet trade": the name given to the practice of piracy, one of the oldest professions in the entire world.

swivel gun: small cannon that is mounted on a swivel and attached to the rail or from the fighting tops of vessels.

"take in": to lower the sails.

treasure: accumulated or stored (hidden) wealth in the form of money, jewels, precious metals or other valuables.

"turn to": to start working right away.

undercurrent: a current below the upper surface of the water.

watch: a period of time, normally four hours, during which a portion of the ship's crew is required to be on duty; a person or persons on watch duty.

"weigh anchor": to raise the anchor.

"where away?": "which way?"

woolding: a commonly used form of torture in which a knotted cord was tied around the victim's head and then twisted with a stick until the victim's eyes popped out.

yard: a long spar (wood) suspended from the mast of a ship to extend the sails.

yardarm: the end of the spars from which sails hang.

Sources by Chapter

Any history of pirates is limited by the fact that, in their own best interests, pirates, unlike other seafarers and government agencies, kept very few written records. Of course, even when meticulous records were kept, the actual inventory of goods recovered from shipwrecks typically far exceeded the official written manifest. So even as we strive for historical accuracy, some of the research may in and of itself be suspect.

Another problem with writing about pirates is the simple fact that those who historically wrote about pirates are suspect when it comes to material or actual facts. There may be instances within this work when we have relied on authors or written sources that may be historically suspect and later proven to be incorrect.

Our intent is to provide the reader with a history of piracy that is as accurate as we could determine. To this end, we are providing the reader and researcher the sources we used along with our own research in the writing of each chapter of this book. We hope that this will be helpful for the reader attempting to research a particular part of this text.

INTRODUCTION

Cawthorne, Nigel. *Pirates: An Illustrated History.* Edison, NJ: Chartwell Books, Inc. Division of Book Sales, Inc., 2005.

Earle, Peter. *The Pirate Wars.* N.p.: Thomas Dunne Books, St. Martin's Press, 2005.

McCarthy, Kevin M. *Twenty Florida Pirates.* Sarasota, FL: Pineapple Press, 1994.

Osborne, Will, and Mary Pope Osborne. *Magic Tree House Research Guide Pirates.* A Stepping Stone Book. New York: Random House, 2001.

Pirateology: A Pirate Hunter's Companion. Cambridge, MA: Candlewick Press, 2006.

Polmar, Norman, and Christopher P. Cavas. *Navy's Most Wanted.* Washington, D.C.: Potomac Books, 2009.

Timelines, Pirates. http://www.timelinesdb.com. The reader simply need enter "pirates" and the dates he wants to explore.

United States Coast Guard. Visual Information Gallery. http://cgvi.uscg.mil/media/main.php.

Wagner, Mark J., and Mary J. McCorvie. "Going to See the Varmint, X Marks the Spot." *The Archaeology of Piracy.* Gainesville: University Press of Florida, 2006.

Historical Background

Cawthorne, Nigel. *Pirates: An Illustrated History.* Edison, NJ: Chartwell Books, Inc. Division of Book Sales, Inc., 2005.

Cordingly, David. *Under the Black Flag.* New York: Random House, 1995.

Earle, Peter. *The Pirate Wars.* N.p.: Thomas Dunne Books, St. Martin's Press, 2005.

McCarthy, Kevin M. *Twenty Florida Pirates.* Sarasota, FL: Pineapple Press, 1994.

Osborne, Will, and Mary Pope Osborne. *Magic Tree House Research Guide Pirates.* A Stepping Stone Book. New York: Random House, 2001.

Pirateology: A Pirate Hunter's Companion. Cambridge, MA: Candlewick Press, 2006.

Polmar, Norman, and Christopher P. Cavas. *Navy's Most Wanted.* Washington, D.C.: Potomac Books, 2009.

Raffaele, Paul. "The Pirate Hunters." *Smithsonian,* August 2007.

Rediker, Marcus. *Villains of All Nations.* Boston, MA: Beacon Press, 2004.

Timelines, Pirates. http://www.timelinesdb.comr.

United States Coast Guard. Visual Information Gallery. http://www.cgvi.usgc.mil.

United States Customs and Border Protection. http://www.cbp.gov.

Wikipedia. "Davy Crockett and the River Pirates." http://en.wikipedia.org/wiki/Davy_Crockett_and_the_River_Pirates.

Wilbur, Kathryn, and T.M. Jacobs. "Skeletons Found at Sword's Point." *Florida Weekly,* January 12, 2011.

Treasure Fleets Bring Pirates to South Florida

Konstan, Angus. *The History of Shipwrecks.* New York: Lyons Press, 1999.
McCarthy, Kevin M. *Twenty Florida Pirates.* Sarasota, FL: Pineapple Press, 1994.
Wikipedia. "Henry Jennings." http://en.wikipedia.org/wiki/Henry_Jennings.
———. "Piracy in the Caribbean." http://en.wikipedia.org/wiki/Piracy_in_the_ Caribbean.
———. "Spanish treasure fleet." http://en.wikipedia.org/wiki/Spanish_treasure_fleet.
Wood, Peter. *The Spanish Main.* Alexandria, VA: Time-Life Books, 1979.

Triangular Trade and the Golden Age of Piracy

African History. "Atlantic Slave Trade." http://africanhistory.about.com/od/slavery/tp/TransAtlantic001.htm.
Columbus Dispatch. "Pirates Buried Racism, Historians Say," December 14, 2006.
Konstan, Angus. *The History of Shipwrecks.* New York: Lyons Press, 1999.
Mel Fisher Maritime Museum. "Reefs, Wrecks and Rascals." http://www.melfisher.org/reefswrecks/slave.htm.
Naval Merchant Ships Articles. "Porter and Pirates: America's Last War." http://navalmerchantshiparticles.blogspot.com/2011/06/porter-and-pirates.html.
Rediker, Marcus. *Villains of All Nations.* Boston, MA: Beacon Press, 2004.
Singer, Stephen. *Shipwrecks of Florida: A Comprehensive Listing.* Sarasota, FL: Pineapple Press, 1992.
Wikipedia. "West Indies Squadron (United States)." http://en.wikipedia.org/wiki/West_Indies_Squadron_(United States).
WT Block. "Pirate Lafitte, Bowie Dealt in Slave Trade." http://www.wtblock.com/wtblockjr/slavetra.htm.

Two Black Caesars

Beater, Jack. *Pirates and Buried Treasure on Florida Islands.* St. Petersburg, FL: Great Outdoors Publishing Company, 1959.
De Los Angeles, Maria. "Trail of the Pirates: Biscayne Bay." http://wlrnunderthesun.org/2011/02/trail-of-the-pirates-biscayne-bay.

The Haitian Revolution and Atlantic Slavery. http://chnm.gmu.edu/revolution/chap8a.html.

McCarthy, Kevin M. *Twenty Florida Pirates*. Sarasota, FL: Pineapple Press, 1994.

Vallar, Cindy. "The Legends of Black Caesar." http://www.cindyvallar.com/blackpirates.html.

————. "Pirates & Privateers: The History of Maritime Piracy—Black Pirates." http://www.cindyvallar.com/piratelinks.html. Wikipedia. "Black Caesar (pirate)." http://en.wikipedia.org/wiki/Black_Caesar_(pirate).

————. "Henri Caesar." http://en.wikipedia.org/wiki/Henri_Caesar.

GOLDEN AGE PIRATES OF FLORIDA

Cawthorne, Nigel. *Pirates: An Illustrated History*. Edison, NJ: Chartwell Books, Inc. Division of Book Sales, Inc., 2005.

Earle, Peter. *The Pirate Wars*. N.p.: Thomas Dunne Books, St. Martin's Press, 2005.

Fort Myers (FL) News-Press. "Endangered Puerto Rican Parrot on the Rise." Sunday, June 26, 2011.

Latimer, Jon. *Buccaneers of the Caribbean*. Cambridge, MA: Harvard University Press, 2009.

McCarthy, Kevin M. *Twenty Florida Pirates*. Sarasota, FL: Pineapple Press, 1994.

Wikipedia. "Charles Vane." http://www.en.wikipedia.org/wiki/Charles_Vane.

Wood, Peter. *The Spanish Main*. Alexandria, VA: Time-Life Books, 1979.

Woodward, Colin. Republic of Pirates, http://www.republicofpirates.net.

ANNE BONNY AND CALICO JACK RACKHAM

Beater, Jack. *Pirates and Buried Treasure on Florida Islands*. St. Petersburg, FL: Great Outdoors Publishing Company, 1959.

Cawthorne, Nigel. *Pirates: An Illustrated History*. Edison, NJ: Chartwell Books, Inc. Division of Book Sales, Inc., 2005.

Cordingly, David. *Under the Black Flag.* New York: Random House, 1995.

Krewe of Bonny Read. "The Legend of Anne Bonny and Mary Read." http://www.bonney-readkrewe.com/legend.html.

McCarthy, Kevin M. *Twenty Florida Pirates.* Sarasota, FL: Pineapple Press, 1994.

Way of the Pirates. "Calico Rackham Jack." http://www.thewayofthepirates.com/famous-pirates/calico-jack-rackham.php.

Wikipedia. "Anne Bonny." http:/en.wikipedia.org/wiki/Anne_Bonny.

———. "Calico Jack." http://en.wikipedia.org/wiki/Calico_Jack.

———. "Mary Read." http:/en.wikipedia.org/wiki/Mary_Read.

The Legend of Gasparilla

Beater, Jack. *Pirates and Buried Treasure on Florida Islands.* St. Petersburg, FL: Great Outdoors Publishing Company, 1959.

Jose Gaspar.net. "About José Gaspar & Gasparilla." http://www.josegaspar.net/AboutJose.htm.

Kaserman, James F. *Gasparilla: Pirate Genius.* N.p.: Authorhouse, 2008.

Kaserman, James F., and Sarah Jane Kaserman. *The Legend of Gasparilla: A Tale for All Ages.* N.p.: Pirate Publishing International, 2003.

McCarthy, Kevin M. *Twenty Florida Pirates.* Sarasota, FL: Pineapple Press, 1994.

Wikipedia. "José Gaspar." http://en.wikipedia.org/wiki/Jos%C3%A9_Gaspar.

The True Facts About Gasparilla

Allen, Gardner W. *Our Navy and the West Indian Pirates.* N.p.: Essex Institute, 1929.

Anholt, Betty. *Sanibel's Story, Voices and Images.* N.p.: Donnelly Company Publishers, 1998.

Beater, Jack. *Pirates and Buried Treasure on Florida Islands.* St. Petersburg, FL: Great Outdoors Publishing Company, 1959.

Bickel, Karl A. *The Mangrove Coast: The Story of the West Coast of Florida.* New York: Coward-McCann, 1942.

Burnett, Gene M. *Florida's Past: People & Events That Shaped the State.* Volume 2. Sarasota, FL: Pineapple Press, 1988.

D'Ans, Andre-Marcel. *The Legend of Gasparilla: Myth and History on Florida's West Coast.* Tampa Bay, FL: Tampa Bay History, 1980.

Gasparilla Pirate Fest. http://www.gasparillapiratefest.com.

Grismer, Karl H. *The Story of Fort Myers.* A Southwest Florida Historical Society Book. Fort Myers Beach, FL: Island Publishers, 1982.

Jose Gaspar. "About José Gaspar & Gasparilla." http://www.josegaspar.net/AboutJose.htm.

Schell, Rolfe F. *1,000 Years on Mound Key.* Fort Myers, FL: Island Press, 1962.

Wikipedia. "Gasparilla Island." http://en.wikipedia.org/wiki/Gasparilla_Island.

———. "José Gaspar." http://en.wikipedia.org/wiki/Jos%C3%A9_Gaspar.

———. "Sanibel Island." http://en.wikipedia.org/wiki/Sanibel_Island.

LAFITTE'S GOLD AND OTHER LEGENDARY TREASURES

American Folklore and Legend. Pleasantville, NY: Reader's Digest Association, 1978.

Barcia Carballido y Zuniga, Adres Gonzalez de. *Barcia's chronological history of the continent of Florida, from year 1512, in which Ponce de Leon discovered Florida, until year 1522.* Translated by Anthony Kerrigan. Gainesville: University of Florida Press, 1951.

Handbook of Texas Online. http://www.tsha.utexas.edu/handbook/online/articles/LL/fla12.html.

Jameson, W.C. *Buried Treasures of the Atlantic Coast.* Little Rock, AK: August House Publishers, 1998.

McCarthy, Kevin M. *Twenty Florida Pirates.* Sarasota, FL: Pineapple Press, 1994.

The Story of Jean and Pierre Lafitte, the Pirate-Patriots. New Orleans: Louisiana State Museum/Press of T. J. Moran's Sons, 1938.

Wikipedia. "Jean Lafitte." http://en.wikipedia.org/wiki/Jean_Lafitte.

KEYS WRECKERS

Along the Florida Reef: Tales of Old Florida. Secausus, NJ: Castle Division of Book Sales, Inc., 1987.

A Notorious Place Florida. http://www.n-the-florida-keys.com/Wreckers.html.

Key Biscayne. "Cape Florida Lighthouse." http://www.key-biscayne.com/about/light.html.

Key West Vacation Guide. "Key West." http://www.keywestvacationguide. com/key-west.php.

Kirk, Dennis. "Key West Boasts a Bloody and Storied past." *Florida Weekly*, 2011.

Lighthouse Friends. "Florida Lighthouses." http://www.lighthousefriends. com/pull-state.asp?state=FL.

Mel Fisher Maritime Museum. "Key West Pirates." http://www.melfisher. org/reefswrecks/wreckers.htm.

Naval Merchant Ships Articles. "Porter & Pirates: America's Last War." http://navalmerchantshiparticles.blogspot.com/2011/06/porter-and-pirates.html.

N the Florida Keys. "Wreckers Were Some of the Wealthier Citizens in the Florida Keys During the Pirate Heydays." http://www.n-the-florida-keys. com/wreckers.html.

Pineapple Inn. "Legend of the Pineapple." http://pineappleinn-na. com/?s=legend+of+the+pineapple.

Singer, Stephen. *Shipwrecks of Florida: A Comprehensive Listing.* Sarasota, FL: Pineapple Press, 1992.

Wikipedia. "Charles Gibbs." http://en.wikipedia.org/wiki/Charles_Gibbs.

———. "Lighthouse." http://en.wikipedia.org/wiki/Lighthouse.

———. "Monroe Doctrine." http://en.wikipedia.org/wiki/Monroe_Doctrine.

———. "West Indies Squadron (United States)." http://en.wikipedia.org/ wiki/West_Indies_Squadron_(United_States).

The Development of Florida and Civil War Blockade Runners

Buker, George E. *Blockaders, Refugees, and Contrabands: Civil War on Florida's Gulf Coast, 1861–1865.* Tuscaloosa: University of Alabama Press, 1993.

Burnett, Gene M. *Florida's Past: People & Events That Shaped the State.* Volume 2. Sarasota, FL: Pineapple Press, 1988.

Department of Military Affairs, Florida National Guard. Second Seminole War. http://www.flheritage.com/facts/history/seminole/wars.cfm.

Fort Myers (FL) News-Press. "Despite Embargo, U.S. Top Food Source for Island," March 26, 2007, A7.

Key Biscayne. "Cape Florida Lighthouse." http://www.key-biscayne.com/ about/light.html.

Lighthouse Friends. "Florida Lighthouses." http://www.lighthousefriends. com/fl.html.

Naval Historical Center. "Confederate Ships—CSS Florida (1862–1864)." http://www.history.navy.mil/photos/sh-us-cs/csa-sh/csash-ag/florida.htm.

Singer, Stephen. *Shipwrecks of Florida: A Comprehensive Listing.* Sarasota, FL: Pineapple Press, 1992.

Wikipedia. "Andrew Jackson." http://en.wikipedia.org/Andrew_Jackson.

———. "Florida in the American Civil War." http://en.wikipedia.org/wiki/Florida_in_the_American_Civil_War.

———. "Second Seminole War." http://en.wikipedia.org/wiki/Second_Seminole_War.

———. "Union Blockade." http://en.wikipedia.org/wiki/Union_blockade.

From Civil War to Prohibition

Babson, Jennifer. "Cuban Migrant Smugglers Find New Launch Spot." *Miami Herald*, May 16, 2005.

Barber, Robert F. "The Day the Coast Guard Hanged a Man." Jack's Joint. http://www.jacksjoint.com/hanging.htm.

Brown, Loren G. *Totch: A Life in the Everglades.* Gainesville: University Press of Florida, 1993.

Burnett, Gene M. *Florida's Past: People & Events That Shaped the State.* Volume 2. Sarasota, FL: Pineapple Press, 1988.

The Carpetbagger. "Brief History of Carpetbags and Carpetbaggers." http://www.thecarpetbagger.com/history.

Caudle, Hal M. *The Hanging at Bahia Mar.* Fort Lauderdale, FL: Wake-Brook House, 1976.

Florida Heritage. "A Brief History of Florida." http://www.flheritage.com/facts/history/summary.

Fort Myers Tropical News. "Alderman Held Criminal Record in Fort Myers, at One Time Acted as Fishing Guide for President Roosevelt," January 28, 1928.

GeneaologyBlog. "A Review of the New U.S. Chinese Immigration Case Files, 1883–1924." http://www.genealogyblog.com/?p=820.

Husty, Denes. "Smugglers Have Centuries-Old History in SW Florida." *Fort Myers (FL) News-Press*, August 6, 2007.

James Horace Alderman Collection. http://www.library.miami.edu/specialcollections/collections/findingaids/m0443_find.html.

McCarthy, Kevin M. *Nine Florida Stories by Marjory Stoneman Douglas.* Jacksonville: University of North Florida Press, 1990.

New York Times. "Havana Boatmen Smuggle Chinese." November 30, 1902.

Time magazine. "Judiciary: Hangar Hanging." 1927. http://www.time.com/time/magazine/article/0,9171,751986,00.html.

Wikipedia. "Carpetbagger." http://en.wikipedia.org/carpetbagger.

————. "James Alderman." http://en.wikipedia.org/wiki/James_Alderman.

————. "People Smuggling." http://en.wikipedia.org/wiki/people_smuggling.

————. "William S. McCoy." http://en.wikipedia.org/William_S_McCoy.

From Prohibition to Present Day

Babson, Jennifer. "Cuban Migrant Smugglers Find New Launch Spot." *Miami Herald,* May 16, 2005.

Brown, Loren G. *Totch: A Life in the Everglades.* Gainesville: University Press of Florida, 1993.

Burnett, Gene M. *Florida's Past: People & Events That Shaped the State.* Volume 2. Sarasota, FL: Pineapple Press, 1988.

California State University Northridge. "CIA: Cocaine Importing Agency." http://www.csun.edu/~hfspc002/news/cia.drug.html.

CBS Miami. "Gun Smugglers Take Aim at Florida." October 4, 2010. http://miami.cbslocal.com/2010/10/04/i-team-gun-smugglers-take-aim-at-miami.

CBS News. Falcon Lake Texas Shooting, October 1, 2010. http://www.cbsnews.com/8301-504083_162-20018299-504083.html. Numerous articles also available from 2011 on topic.

CIA Involvement in Drug Smuggling. http://www.thepeoplesvoice.org/TPV3/Voices.php/2008/12/12/a-brief-history-of-cia-involvement-in-drugs.

Florida Weekly. "Off the Radar, Semi-Subs: A Sneaky Tool for Smugglers, Terrorists." March 20–26, 2008.

Husty, Denes. "Smugglers Have Centuries-Old History in SW Florida." *Fort Myers (FL) News-Press,* August 6, 2007.

Miller, Glenn. "Marijuana Smuggler Cashed in, Paid Price." *Fort Myers (FL) News-Press,* June 26, 2011. http://news-press.com.

New York Times. "Coastal Drug Running." http://www.nytimes.com/1987/02/28/us/coastal-drug-running-is-luring-adventurers.html.

————. "From Brazil to Peru to Jamaica, Gun Smugglers Flock to Florida." http://www.nytimes.com/1991/08/11/us/from-brazil-to-peru-to-jamaica-gun-smugglers-flock-to-florida.html?pagewanted=all&src=pm.

Palm Beach Post. "South Florida Becoming Gateway for Arms Smuggling." September 19, 2010. http://www.palmbeachpost.com/news/crime/south-florida-becoming-gateway-for-arms-smuggling-924930.

Raffaele, Paul. "The Pirate Hunters." *Smithsonian*, August 2007.

St. Petersburg Times. "Refugees Speeding to U.S. Shores." June 6, 2005.

Tampa Tribune. "Border Rat's Distress Call, Views." February 21, 2009. http://www.tbo.com.

U.S. Drug Enforcement Administration. http://www.usdoj.gov/dea/index.htm.

About the Authors

James F. Kaserman first learned of pirates in 1956 and became interested in the truth about pirates when doing research studies of government and business organizations. He concluded that pirate organizations had many similarities to the businesses of today and even served as models for our modern-day democracy. Jim believes that, like all illegal enterprises that have survived thousands of years, piracy is an ongoing institution and will exist so long as there is potential for greater economic reward to those who participate.

Following graduation from Washington High School in Massillon, Ohio, he earned a bachelor's degree in business administration from Kent State University and a master's degree in educational administration from the University of Dayton. He was honorably discharged with the rank of staff sergeant from the United States Army. Jim was a teacher, coach and administrator for thirty-six years and spent ten successful years as an elected official. Jim is a former professional race car driver and still drives stock cars with the Daytona Antique Auto Racing Association.

Sarah Jane (Chenot) Kaserman was an educator for more than thirty-five years and recently retired as a teacher of gifted students in the Lee County

School District in Florida. Following graduation from North Canton Hoover High School in North Canton, Ohio, she earned a bachelor's degree in elementary education and a master's degree in deaf education from Kent State University. A violinist and fiddle player, Sarah Jane likes to read, travel the country and play old-time, folk and bluegrass music. Sarah Jane and her grandfather's fiddle, "Charley," can be found at all presentations that the Kasermans put on regarding their series of pirate books.

Together, James and Sarah Jane have combined their years in education with the vision of writing multisensory books and have written many elementary Accelerated Reader books. They have written three pirate books, *Gasparilla: Pirate Genius*, *The Legend of Gasparilla: A Tale for All Ages* and *How the Pirates Saved Christmas*. Each of these works has won a number of awards. Their book *Pirates of Southwest Florida: Fact and Legend* is used in their teaching with the Florida Gulf Coast University's Renaissance Academy.

They have been happily married since 1966 and are the parents of two sons, Richard and James, and grandparents to James Hunter, Reed Samuel and Haven Jade. They have lived in Fort Myers, Florida, since moving there from their native Ohio in 1985.